For
Valerie

Tom Hutton

1985

How I Photograph People

For Mari, Georgina and William

How I Photograph People

TOM HUSTLER

Focal Press · London

Focal/Hastings House · New York

 British Library Cataloguing in Publication Data

Hustler, Tom
 Tom Hustler on—how I photograph people.
 1. Photography—Portraits—Amateurs' manuals
 I. How I photograph people
 778.9′2 TR575

ISBN (excl. USA) 0 240 51027 5
ISBN (USA only) 0 8038 3055 6

First Edition 1979

Printed in Great Britain by A. Wheaton & Co. Ltd., Exeter

Contents

1

Introduction

Why do I photograph people instead of things? I suppose at heart I have always been a commercial artist... one tin of baked beans looks very much like another to me but every face is different. Everybody's personality is different. Everyone's body is different. To shoot commercial 'package' shots of bottles of wine, electric drills, plant and machinery or whatever, you have to be a very good photographer. To shoot people you have to be something more ... a director of personalities; a comedian; an amateur psychologist; an entertainer; a keen observer of people's characteristics, eccentricities, mannerisms, expressions and everything else that makes up that complicated being ... *a person*.

Because it is more difficult, it provides a greater challenge. The greater the challenge the greater the feeling of achievement when one succeeds...

Being a photographer of people is like being a comedian on stage with a live audience. A comedian can judge his success by the number of laughs he gets and the applause. For the photographer, the results of the pictures will also produce applause, in a different way. If he has been shooting shots of characters at a yachting regatta and shows the results at his local camera club, his audience will soon tell him by their reaction whether or not he has 'caught' the fun of it all. When asked to shoot a sitting of some children for someone else, he has to please himself and the children's family. When the family orders masses of pictures and has them framed all over the house, he has done a good job.

When I started in photography and tried to take beautiful views, friends used to say 'That's a nice picture, what's on TV?...' I never knew if they meant it. When I photographed their children and they ordered extra copies I *knew* they meant it!

Even when shooting travel pictures I found that including people in pictures and shooting closeups of the characters of the country, brought the whole set of pictures to life. Even now I love to photograph candid shots of characters on the beach, 'sporting types' at Henley

Royal Regatta, 'sailing types' at Cowes Regatta, and particularly the local faces of the Middle East and other parts of the world. Even in studio portraiture, where the background is plain and the client usually wants a good 'mug' shot, everybody's face and expressions are different . . . I have photographed several Governors of the Bank of England . . . do you think they looked alike? Never!

The art of the photographer of people is not that of the painter. A painter can get to know his subject over several sittings and choose just one expression. A photographer can shoot (say) 30 or 40 pictures, coaxing him into different moods and expressions, but he also has to relax him and get to know him in that short time. Usually he can pick the six or so that in his opinion are the best likenesses, including the best cheerful and the best serious expression. He can bring out, in that short time, different sides to the character.

I once did a set of a teenage girl. From the six 'blown-up' proofs, granny picked the one of her looking young and charming as the best likeness; mum picked the most natural one; father picked the most grown-up one; the boyfriend picked the sexiest one; I picked the one I thought summed up her general looks and character and the girl herself chose the most flattering! Who was right? They all were. They all thought their choice was the best likeness!

Everybody's face changes expression and all the abstract feelings can show in those expressions. That is why it is not always necessary to show people in their surroundings. Jorge Lewinski would probably not agree with me, but he is usually taking artists, writers, musicians and such like. With them, their surroundings help sum the character up. I do the same with children. I always try and avoid 'studio-type' pictures but I shoot people in their own home or garden. On the other hand one business man's office is very like another so I often choose a plain wall and in case it is covered with a ghastly wallpaper take a portable background. He needs a good face shot which will

reproduce anywhere on fine art paper or even blotting paper when printed!

Pictorialism is fine as far as it goes. I am afraid it does very little for me. I like looking at a beautifully shot sunset, a lovely sky with interesting clouds, a tree silhouetted or dramatic scenery. To record a beautiful subject such as a flower or sunset is to automatically make a beautiful picture. The art of photographing people is to 'handle' that moving living object and still make an interesting picture.

2

Brief Autobiography

Since so many people on a first meeting, ask 'When did you first become interested in photography?', 'How did you become a professional photographer?', 'Was it always your hobby?', 'How did you become famous?' and so on, I think it is best to sum it up as briefly as possible now.

The 3rd October 1934 was an uneventful day for the world. I was born! 'Your wife has just given you a son,' said the doctor to my father. 'Bring me a large whisky and soda, 'said my father to Watson the butler. (It was that sort of household!) It was a big house which had a distant nursery wing, where the children were kept well away from our parents most of the time. My late father's trust money was not well invested, so gradually disappeared, but I was privately educated at Aysgarth School and Eton. I had no choice in the matter. In fact, it was the normal procedure.

I was a hopeless schoolboy—no good at games; average at work. It was in the days when, to be good at work, was considered by the other boys to be 'wet' but, to score a century at cricket was thought to be fantastic. I could never understand it. I just thought that those who did were better at cricket!

The only thing I was good at at Eton was pottery! I even won a prize for it. Also, already being commercially minded, every holiday, I sold the pots to a local shop, for about £5 the lot. This was 100 percent profit, because my parents paid the school expenses!

There was bullying at Eton (I am told not so much now). When I *could* not run fast enough, while training for football, the bigger boys beat the backs of my knees with nettles. It hurt.

Next followed three months with a French family in Bordeaux, during which time I tried to learn as *little* French as possible, having, at that time, no interest in the subject. I was then drafted into the army for National Service but I was completely the wrong shape to be a soldier of any sort. I am 6ft 3in tall and then weighed 10 stone (140 lb). None of my 'uniform' fitted. It was not surprising when the Sgt. Major came up behind me on

parade and said "''ustler! You 'orrible man, you are such a disgrace, your mum must be the only person in the world, that loves *You!*''

After much agony, I eventually became an officer, and went off to join the Somerset Light Infantry in Malaya. I still cannot work out why they made very immature, 19-year-old boys into officers, in charge of men's lives, in the jungle looking for Communist terrorists to kill. We were trained mentally to hate them and knew they were there to kill us if we did not kill them, but I decided to rely for advice on my experienced NCOs. However, in the middle of the tropical jungle, the decisions were mine.

It was a bit like *The Virgin Soldiers*. But they were in base camp most of the time and we were out patrolling and ambushing, with little effect. During my year there, my platoon happened to kill two Communist terrorists, but I cannot say I enjoyed it—purely self-preservation. In many ways the bandits were trying to avoid us and we were trying to avoid them!

However, during this time I bought a reasonable camera, a folding Zeiss Ikonta M (120 film) and used the pictures to illustrate my long letters home. With this kind of amateur photojournalism and many back numbers of *Amateur Photographer* magazine belonging to one of my friends, I became very interested in photography. (I am finally now using this method to help train my assistant who knew nothing of photography before he arrived.) I discovered the relationship between shutter speed and aperture, the (ASA) speed of film and the importance of *knowing your camera* and what you can do with it.

My subjects were mainly the people of Malaya and, of course, my Army friends. The people, against varied backgrounds, were my record of those very valuable and educative months. The subjects were all around. I went on leave to Penang and Bangkok. The people, the temples, the canals, the rickshaws—all these were marvellous camera fodder. I had them developed and enlarged to 3×3 in, and even 6×6 in by the local Chinese photographer who sometimes used to let me 'help' him in his darkroom.

('Please, Sah, throw in a couple of handfuls of hypo crystals. The soup is getting a bit weak!') That was in 1954 and I still have the pictures in albums. They have not faded yet!

After National Service I came home, still with no idea of what I wanted to do with my life. It was suggested that I should join a firm of stockbrokers in the City of London, and, since most of my contemporaries were either in the Stock Exchange or at Lloyds, I agreed to become a trainee clerk at £6 per week.

Photography, for a while, held no further interest for me. The subjects at home all seemed mundane compared with the Far East. Over there when I had kept a photographic record and illustrated my long letters home with my pictures, there was some *point* to it all. At home I only took a few pictures of my young brother and family. For the first two years in the Stock Exchange I slogged away in the city during the day and, as soon as possible, joined the deb dance circuit at night. We all did this since we needed the food as well as enjoying the free champagne and female company! The friends and contacts I made then also came in very handy later.

A friend of mine once wrote to his laundry, 'The excellence of your laundry is only surpassed by the perfection of your button crushing machine!'. In my case my inefficiency as a soldier was only surpassed by my incompetence as a stockbroker!

I started taking pictures with simple floodlights in the sitting room of the flat I shared with a couple of chums. The subjects were mostly girlfriends. (It was cheaper than taking them out to nightclubs!) A friend from the Stock Exchange used to bring his girlfriends along as well. I was thrilled when one of them wanted to buy some extra copies, and I charged the enormous sum of 1/6d per copy. It meant that she really liked them and I had succeeded.

I taught myself lighting from books and magazines. I admired Cornel Lucas' style of 'film still' portraiture which was flattering. The films were developed under the stairs and hung over the bath to dry (not very popular

with my flatmates!). Printing sessions the following night in the stuffy little cubbyhole under the stairs, were not a healthy activity either.

All this combined with the fact I hated the city, the smelly Underground trains, the rush hour, the drudgery and sameness of the work made me ill. My doctor said 'Tom, you are a thoroughly unhealthy young man. Take a week off and get out into the fresh air and get some exercise.' So I stayed at home and watched television for a week! During this week my family and friends suggested I left the stock exchange and had a go on my own at becoming a photographer.

It was a pretty big step to take, although I had a few thousand pounds from a family trust to risk. Only Tony Armstrong-Jones had succeeded from my sort of background. He had made photography as a profession acceptable to a certain extent, but mostly the studios were formal portrait affairs surprisingly often run by women (Dorothy Wilding, Madame Yevonde, Madame Harlip, Vivienne). Baron, with whom Tony had trained and met some of the Royal Family, was very ill and died soon after. Cecil Beaton was taking pictures but making more money as a designer (*My Fair Lady* and many others). Press and magazine photographers were not as important as the writers. Fashion photographers were considered effeminate, like dress designers. Now the opposite is true!

So which branch of photography should I try for? My grandmother gave me a Rolleicord and I liked photographing people and children. I had lots of friends in the 'debby' set so I decided to be a formal and informal portraitist.

I struggled along, working from the house I shared in Chelsea. I could take reasonable pictures of a good amateur standard. But how to sell them? Where to find the work? I had to say to everybody 'If you don't like them you need not pay.'

Then I was given some good advice. A good friend of mine, Christine Burges, asked me if I would like to meet Tony Armstrong-Jones, whom she had known from

childhood. I jumped at the chance, saved up 18/- for half a bottle of whisky, and collected together my best prints. They both came round to my house, and looked through my amateurish efforts. He was charming, polite and helpful. His advice was, 'Get together some more samples and try and get a job with an established studio, even if you are paid very little. You need to learn the professional side. Try and pick one which does the type of work that you eventually want to do'. This is still the advice I give aspiring photographers today.

Dorothy Wilding

By now it was 1957. After a few weeks someone told me that Dorothy Wilding was advertising for a 'Student/ Partner'. I applied, had an interview, waited and was offered a pretty poor deal. *I* was to pay *her* £250. I would get commission only on the sittings I produced. I knew it would be a good place for me to start because she specialised in society portraiture and was also a famous royal photographer.

I phoned Tony who said 'Try some other photographers saying that you have been offered a job by DW but you cannot afford her terms.' Houston Rogers offered me £5 per week to start in the darkroom and learn the business. I went back to DW saying I would much prefer to join her but could not afford to. DW matched Houston Rogers' terms and I started with her studio as a darkroom boy.

DW's method of taking portraits was to use a huge 10 × 8 in plate camera with a half plate back on it. The slides were loaded with $6 \times 4\frac{1}{2}$ in cut film. She had two large and one small flood the camera side of the sitter and three small spots behind. She was the master of the formal pose with the informal expression. She told me she learnt her posing and (to some extent) lighting techniques from studying the 'old masters' in art galleries. Her studio consisted of a large reception room with a grand display of her work, including her most famous sitters, a dressing room, a large studio, workrooms, darkrooms and negative

retouching room. She had about 9 staff. She lived in a flat above the studio.

Every negative taken was developed, contact printed and sent up to her for 'lining' and choosing the best six or eight shots. Each chosen shot was then retouched on the negative, printed with some soft focus and again passed by her before being sent as a *proof*. No client was ever allowed to see an unretouched rough proof. When they ordered at about £20 for three pictures (including the cost of the sitting) each chosen negative was again retouched, printed and print finished (retouching on the print), mounted in her own special way three times and then delivered. To give the same service these days, even if one could find retouchers skilful enough, would cost over £100. There are simply not enough people who want to pay such money for this kind of work. Nowadays we take more pictures on a $2\frac{1}{4}$ in sq camera (Rolleiflex. Tele Rollei), light for flattery, slightly diffuse the rough proofs and only do minimal retouching on the end result. We have been lucky in the fashion changing to more natural (but never unkind) pictures.

Trouble between myself and DW soon developed. (She died, by the way, in 1976.) Her business had ceased to be profitable. She thought I was rich, and well connected, and would bring her in lots of extra business and that I would be a general advantage. She was wrong on all four counts!

In 1958 she realised her mistake, and offered to sell me her name, her negatives and the business, but would not show me any books or accounts. This helped me knock her down from £6000 to £3000, and even then I was taking a huge risk, by guaranteeing to keep up her style and standard of photography for some years and by taking on 5 of her staff and half her premises at £1000 per year rent. I was not fully trained by any means, but, by keeping on some experts I relied on and learnt from them.

I soon increased the amount of work I did with Rolleiflexes, started shooting parties and dances for *The Tatler*, *Queen* and *The Sketch*, developed my own style of wedding

15

photography and did as much as I could to get my work published in the newspapers and magazines. The press gave me enormous coverage when I took over from DW on the lines that 'How can a gangling Old Etonian Deb's Delight of 23 take over such a traditionally superb business after only 6 months training?' It made good copy for the papers in those days and, although not all flattering, helped me get known.

My next big break came when Tony Armstrong-Jones announced his engagement to Princess Margaret. I had already photographed Prince Charles and Princess Anne for National Savings Stamps (through the Dorothy Wilding name and because Tony could not do them for obvious reasons). The press were caught short of anything to write about Tony, so they wrote me up (quite inaccurately) as the 'next Tony'. However it all put my name in the papers and helped my career.

Because I still had the DW staff and service, most of her old clients, including some Royals, trusted me and I took some of the official pictures at the wedding of Lady Pamela Mountbatten to David Hicks, and formal and informal pictures for the families of the Duke of Gloucester and the Duke of Kent.

I found a way into the theatre business of taking pictures for such stage productions as *Flower Drum Song* and *The Sound of Music* at the Palace Theatre in London. I was conned into buying a restaurant/discotheque . . . I gave mad parties for publicity and fun I tried glamour photography for the newspapers to fill in the slack winter months . . . The wedding business grew . . . and then in 1972, when I was 37 I found the girl I wanted to marry . . . persuaded her and we have one boy and one girl!!

3

The Art of Photographing People

There are many sides to the art of photographing people. First and foremost—anyone who attempts it should first learn to use his camera and equipment so quickly and efficiently, that, when he starts on human beings, the technicalities of focus, exposure and sometimes lighting do not get in the way of choosing or organising the subject. This is a skill or a craft almost more than an art and can be practised on flowers and animals before attempting people. So many photographers try and run before they can walk and, for instance, attempt glamour before they can take a sharp picture of a house! The new automatic cameras help the beginner over this hurdle. But even some of these almost need a computer operator to work them, and they all have to be studied, tested and practised with before being used on an important subject. You would be surprised how few people actually read the instruction book properly when buying a new camera. Even professionals should do so when buying a different model. A Canon F1 works quite differently from a twin-lens Rolleiflex!

Firstly, the best person to explain a camera to you is the dealer in the shop, he should be an expert in what he sells and, in my opinion, it is always better to buy from this source rather than through the post or from a supermarket. Secondly, when you get home, read the book slowly with the camera unloaded so that you can find all the little knobs and buttons the book mentions. Thirdly, shoot several reels of film and wait to see the results before shooting the next one and, if possible keep notes of exposures, shutter speeds and lighting conditions, which will help you see where you went wrong. All this should be done whether you are starting from scratch or changing models or even the type of film you are using.

When Kodacolor 400 was introduced, it sounded like the wedding photographer's dream, but initially I still put through test reels amongst the Vericolor, to find out its characteristics, before attempting to shoot a whole job on it.

You may think I am stating the obvious but it is vitally

important to know your technicalities and to be able to shoot without dithering about with meters and lens changing in the middle of a session. A still-life photographer can take as long as he likes to shoot but a portrait sitter, for instance, can get very bored and irritable with an obviously slow and inefficient photographer.

People can be photographed in two basic ways—two very different types of photography. The first to try is the candid or photojournalistic approach where the subjects do not know they are being taken. This can be attempted very soon after the first few test reels, because if they do not know they have been taken people will not complain if you make a mistake and they do not come out! The place to try this type of photography is on holiday, in the local street market, an outdoor event such as a carnival, a sports event, horse racing etc. It is fairly easy to be unobtrusive when there is a lot going on and many other people are handling cameras. A normal camera with a standard lens is usually perfectly adequate for shooting these pictures, and you soon learn some of the professional tricks. One is to focus on something the same distance away as your 'target' and after watching him out of the corner of your eye for the right moment, swing round and at the last minute, click and turn the camera away as if you were just looking for a picture!

The second way to photograph people is with the organised or posed picture method in which the subjects know they are being taken. This includes portraiture, family pictures, groups and weddings (although at the latter I usually fire off a couple of rolls of fun candid pictures as well). For this far more skills are needed. The arts of the comedian, film director, crowd controller, fool, buffoon are necessary at times as well as being an artist with an eye for shape, form and composition. This is where speed and efficiency with basic technique of camera handling becomes absolutely vital. The professional also needs the arts and skills of a businessman and publicity man.

Good composition is a must in every picture taken. Here is a nicely balanced picture of a bridesmaid.

Composition

A word about composition. Older readers may remember Ricardo of *The Amateur Photographer,* who, twenty-five years ago or so used to have a weekly column in which he analysed true composition, and its faults in various photographs. I learnt a lot from him, and from my sister, Jo, who was then an art student and now is an art teacher. Basically, composition is a question of balance. If the subject matter is unbalanced it will offend the eye (even to an unknowledgeable observer who does not know what is wrong but just does not like the picture). Every picture taken should be well composed. I must admit that, after taking about half a million pictures, composition comes almost automatically to me!

However, there are many mistakes that are only too easy to make. Many people forget the background when shooting a person. But the background, in or out of focus, is still part of the final picture. How often have you seen vases growing out of people's heads, hideous drain pipes splitting a picture, grandparents with no feet, aunties

with no heads and so on! The basic rule is to keep backgrounds as simple as possible but, if you do have to have them in the picture, make them part of the composition or a good frame for the subject. I found that, once I had learnt the basic rules of composition, they were always there in the back of my head, and even if I tried to break them on purpose for a special effect, the picture always ended up being balanced and easy on the eye.

Composition in portraiture

There is one basic rule which is worth mentioning about the placing of a face in a head and shoulders portrait. Never have a face looking or falling out of a picture. Take a standard pose with the shoulders turned away, the head slightly more towards the camera and the eyes into the

This very well composed head and shoulder's portrait of Nicholas Parsons is achieved by positioning his head so that the inside corner of the near eye is centred in the picture.

camera, the centre point (up and down) should nearly always be the inside corner of the nearer eye. This applies even if you have to crop a girl's long hair on the back of her head. You will be surprised how well this rule works. Even profiles should not have the nose stuck up against the side of the picture frame. The most interesting part of the picture is the eyes and face. Nobody wants a picture with three-quarters of it filled with hair. Another, not so accurate, way of putting it is always to crop a portrait with more plain background in front of the head than behind.

There is a great art in posing the sitter well. It looks stiff and unpleasant to the eye to sit a person with the body, head and eyes all facing the same way like a passport picture. The body turned away, the head turned, and sometimes tilted forward a little and the eyes looking into or near the lens is much better to look at. I personally like my sitters looking into the camera for most shots. With this technique I can catch expressions I conjure up from them and the final result looks as if the sitter is looking at the viewer of the picture. It is much more personal, particularly for politicians and businessmen.

I suppose you could add to the list of desirable skills the art of a psychiatrist. Before any session one must ask oneself, 'What is the object of the portrait and what is it going to be used for?'. If it is for use in an exhibition or competition the subject must be chosen by you. Find a great character face or a very pretty girl who knows how to make up well and go for a stunning picture. On the other hand if you are asked to photograph the 'girl next door' for her mum, you need a nice natural-looking portrait, which will look good on display in the home. It is quite an art choosing what type of picture you are going to take.

Recognition and creation

As well as all these minor skills and arts already mentioned, the style required for photographing people can be

divided into two, one for each type. For the candid shots one needs the art of recognition.

Recognition is simply the ability to recognise a good picture when you see it. In many forms such as car, motorbike or horse racing, it means anticipating a picture before it actually arrives in the viewfinder to make the perfectly composed and timed action shot. Recognising a subject is sometimes made easier by searching for it through the viewfinder, especially through a reflex camera in which the focusing screen converts real life into a two-dimensional picture.

Creation is more difficult, because there is more to think about. Much of this should be done before the 'model' arrives. Taking pictures of a bride at home before she leaves for the church for instance. I arrive at her home early, choose my background, set up my lighting and decide how to pose her before she comes into the room. With a few minor adjustments of pose and lighting for different effects, all the time I have with her, can then be used to concentrate on her and the one-to-one relationship between photographer and subject, so that she hardly notices the machinery involved.

I can achieve this even better if I can shoot out of doors, where I can choose a couple of locations, work out my exposures and how I am going use the available light. I might even get away with using only a camera. I managed to cover some weddings from start to finish with one camera while all my spares and my whole studio set-up is in the boot of my car in case it is needed. Equally with close-up portraiture, the basic set-up, lighting, cameras, exposures should all be set up and worked out before the sitting starts.

I thought of this simple pose with window lighting before the bride was ready, so I did not waste any time when she was for shooting.

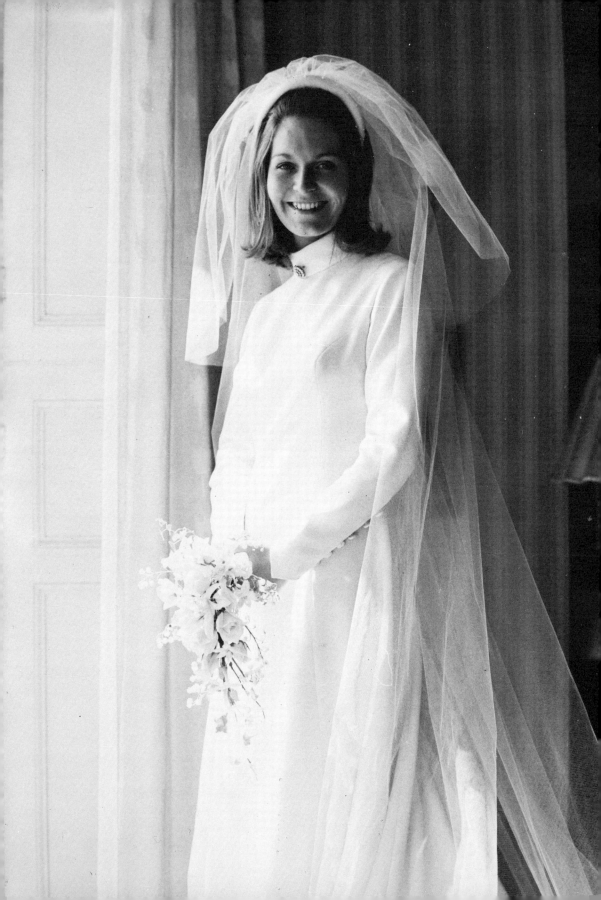

4

Cameras and Equipment

Generally speaking, the best camera for any situation is the camera you know how to use best! I have met so many people whose expensive cameras spend all their time in a cupboard because they don't know how to use them. Sometimes I suggest they sell them and buy an Instamatic instead, and they start taking masses of marvellous family pictures!

Beginners should obviously start with a simple camera. By simple I do not neccessarily mean automatic. I think anybody who wants to become a reasonably good photographer should understand the rudiments of how to work a camera with adjustable focusing, aperture or ƒ stops, and shutter speeds. They should learn a little about depth of field, the difference between a wide angle and a telephoto lens, over- and underexposure, fast and slow films, the different uses of black and white, colour negative and colour transparency films and so on. I do not intend to go into all this from the start and there are many beginners books on the subject. (*Starting Photography, Better Photography, Colour in your Camera, The all-in-one Camera Book, Commonsense Photography* all published by Focal Press.)

I have to assume that you already have a general grounding in photography or at least know how to use your camera and can achieve fairly consistent results, technically.

110 and pocket cameras

These are perfectly adequate for snaps, but don't expect to get high quality enlargements from the negatives.

35 mm cameras

There is a vast range of cameras using this size film on the market and the big producers are competing with each other all the time to make better and better machines. The lenses are designed by computers, the shutters and exposure meters are worked electronically, and they are

trying to make everything possible, easy and automatic, even the focusing, although how the poor camera knows what part of the subject you want to focus on goodness knows!

I have no idea how these, or any cameras actually work, what I *do* know is how to work the camera of my choice, and I think this is the vital point. So many photographers I meet and read about in the magazines seem to be much more interested in their machines than the pictures they want to take. Whoever heard of a painter being more interested in his canvas, brushes and paints than in his subject. He picks the right equipment for the subject he wants to capture, and so should a photographer.

When I started in photography professionally, the press boys were still using plate cameras and a few adventurous ones 120 film size. Now they all use 35 mm size, usually Canons or Nikons—the reason? The quality of camera and film has improved enormously and the ease of carrying a selection of gear plus different lenses which might be needed on a press assignment, makes 35 mm the ideal press and photojournalistic format. Who else uses 35 mm in the professional world? The fashion photographer, the magazine photographer and, some of the time, the advertising photographer. I say *some* of the time because the person taking still-life pictures of cookery, bottles of booze, room sets or any-thing that needs superb sharpness and quality still uses huge plate cameras with slides taking up to 10 × 8 inches cut film. I personally use my 35 mm Canon F1, which has a range of lenses, for all transparency work intended for projection and copying and with colour negative film for family snaps. I have never been very happy with black and white results compared with those produced by my 120 sized Rolleiflexes.

120/220 film cameras

These are much bulkier and heavier than their 35 mm counterparts. They are also mostly more expensive. One

gets fewer shots per film or per £1 than on the smaller sizes. However, the larger sized film can take in so much more detail and enlargements give so much more sharpness and less grain, that it makes them ideal for portraiture, weddings, high quality fashion, transparencies for glamour, transparencies for sale through agents and libraries (although many are accepting really high quality 35 mm) and any subject where *quality* really counts.

I know many 35 mm enthusiasts will disagree with me about this but I have proved it to myself many times over. The reason press men use the small negative size has been mentioned. But there is also the additional reason that in most cases only one or two pictures are needed from each negative and the final prints are then made into blocks or published on bad quality newsprint which loses much of the detail in any case. A private photographer often has many different orders from the same negatives and the 120 size certainly stands up to frequent handling and is less prone to dust collecting.

There are many arguments for and against the various sizes so really one has to work out what type of photography one wants to do and then buy a camera of the format size most suitable for that.

My equipment

I happen to own seven twin lens Rolleiflexes. Why seven? Because I stopped selling or part exchanging, in order to keep spares of each type. These can be kept in condition with a service every one or two years or when one breaks down through sheer hard work. I have four standard Rolleis, two Tele Rolleis and a wide-angle Rollei (now out of production). The lenses are not interchangeable but, to put it a different way, each lens has its own shutter and body. The standards are used for weddings, child photography, and any other job which needs a standard lens. The Tele Rolleis with Proxar close-up lenses attached are my main instrument for close-up portraiture. The lens on a Tele Rollei has a focal length of 135 mm. I also like

I used a Tele Rollei which has a 135 mm lens for this on-stage shot of Danny la Rue.

26

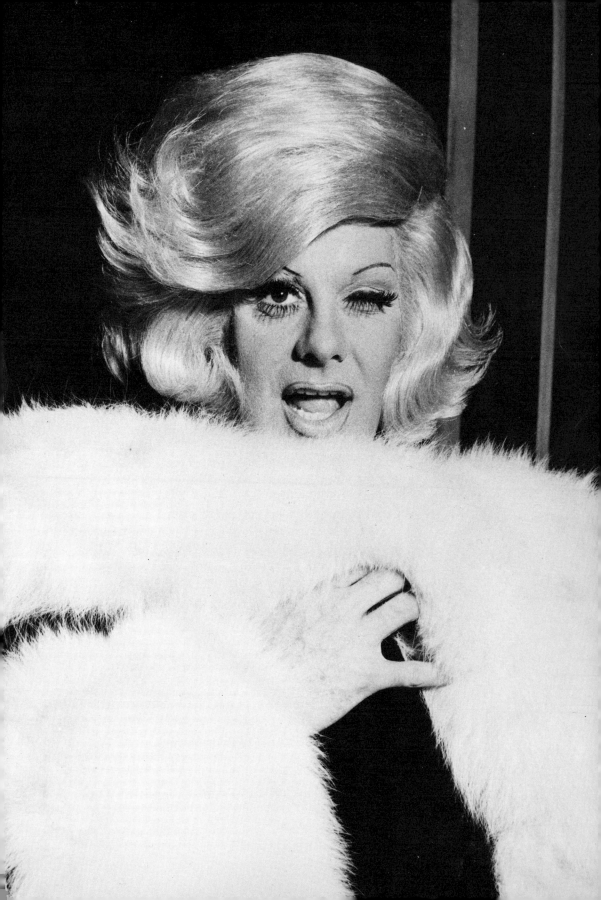

to use these cameras for three-quarter length portraiture and glamour, without Proxars but always with a lens hood.

I also use the tele for shooting action shots in the theatre when commissioned by the producer to take the 'front of house' and publicity shots for reproduction. The wide-angle Rollei comes in very useful for the times I have to shoot large groups in small rooms or small groups in large crowds. I could not replace these cameras if I were starting today, nor could I afford to! I think if I had to start again I would take a close look at the single lens reflex range of Hasselblads, Mamiyas, Bronicas etc., but would always have a standard Rollei up my sleeve.

One person who came on one of my photographic courses was a long distance truck driver. It turned out that he owned two Hasselblad bodies with a variety of lenses and sixteen film magazines! An amateur can risk owning one camera with several lenses but anybody taking on paid or even serious work must have two or more bodies/shutters as well as the different lenses. If the body does not work your lenses are useless.

I also have two Canon F1 bodies with four lenses including a fabulous 17 mm wide angle. I have a Zenith Sniper with 300 mm lens, stock and pistol grip, making it look like a machine gun—it is a bit of a toy and seldom used.

Zoom lenses

There is a growing popularity for zoom lenses. I find this marvellous to have on my family Super 8 cine camera but have never needed one for my still work. They tend to be heavier and more cumbersome than prime lenses, especially if they have macro facilities. But with all the impressive hardware available today keep a sense of proportion. Just because you own a motor driven 'super 35' with 'macro zoom special' and a 250-frame film back, it does not mean you are a good photographer!

Two studio flash heads in front and one on his hair lit this picture of Danny la Rue.

Flash and other equipment

When I started taking pictures, both as an amateur and a professional, electronic flash was in its infancy. Photofloods and bulbs were the 'order of the day'. Dorothy Wilding used two huge 1500 watt floods to provide general illustration, one photoflood 'modelling light', and three little spotlights (placed behind the sitter to light the hair and the background) for her portraiture. Before I joined her I used three photofloods in rather bent and bashed reflectors on rickety stands. I used her lights and learnt her technique, but soon adapted it to the facial lighting I preferred. The great disadvantage of the big floods was the heat and the brightness in the sitter's eyes which often made them squint. Also one normally had to use a rather slow shutter speed and a large aperture, so the subject had to sit very still, to avoid blur or moving out of the limited depth of field. This was not the best situation to get happy or informal expressions, but DW and Marcus Adams, the great child photographer, seemed to work miracles.

Miss Wilding never used the Rolleiflex (although her contemporary Cecil Beaton put one to very good use, and Cartier Bresson was shooting with a Leica from the time it was invented). Her technique was entirely based on the large studio plate camera, with an assistant to focus and another to move the lights.

Nowadays all that has changed, although it took a long time. The big studio flashes were first used by fashion and advertising photographers, and now most portraitists are working with them.

I gradually changed over to large studio flash (a Bowens Multilec) and this had a central 'box' into which were plugged about four separate 'heads' on stands representing the frontal floods and back spotlights. I started using this with the old plate camera for portrait sittings and with the Rolleis for other jobs but eventually gave up the plate

This shot of Terry Scott was taken with tungsten studio lighting– –two 1500 watt filtered floods and a third 'modelling light'. (Note the highlights in the eyes.) One spot was placed on the background, and one on his hair.

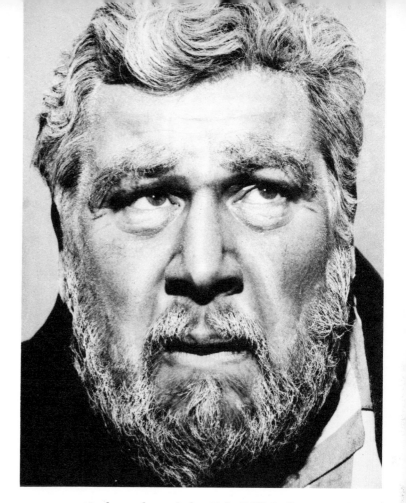

One portable battery flash was all that I had to photograph Peter Ustinov in his dressing room in the theatre. (He was made up as an old man in the play *Photo Finish*.)

camera entirely and used the Tele Rolleis for portraiture. This meant that the negatives could no longer be retouched as well as the prints. On the other hand, all those processes were becoming very expensive. Instead I concentrated on flattering lighting and good expressions.

The type of flash set I have just described is now virtually obsolete and manufacturers produce a wide range of electronic lighting units which are individually powered by the mains. Instead of working from a central 'tinder box', the heads each have a 'slave unit' or independent triggering mechanism that fires at the same time as the other heads when it picks up the other flashes into its 'magic eye' sensor. They are marvellously portable and I can get my whole studio set into the boot of my car.

Many of these companies also make a more powerful studio set up with a 'tinder box', which is fine for big professional commercial studios but beyond the needs and pockets of most amateurs and small scale photographers, like me!

31

The advantages of the portable, mains-fed electronic units are many. There is a modelling light which gives one a rough idea of the lighting on the subject if the room is dark. The flash is about 1/1000 sec in duration, which cuts out any camera shake or subject movement. The flash itself is of the same colour quality (colour temperature) as normal daylight. It is also more powerful than the photofloods, enabling one to use apertures of f11 and f16 instead of f5.6 or f8.

The only disadvantage compared with photofloods, is that it is more difficult with flash to judge the final result of the lighting even with the help of modelling lights (low power continuous burning lamps fitted into each head allow lighting to be arranged visually). With practice this becomes only a minor nuisance.

For portraiture, I really cannot recommend the smaller battery flashes, which flood the market, even with 'brolly' attachments. I have seen some fair results from people who have really researched and practised with their equipment but, to my mind, the smaller battery-powered flash are best used for informal pictures including family snaps (yes I still take them!), child photography, parties, weddings and so on.

The only time I break this rule myself is on stage at a rushed, 'posed' photocall for a production when I have no time to set up big equipment and don't want to use the theatre lights for close-ups.

The portable flashes I work with are made by Metz (the 402 model) and are wet accumulators or the nickel cadmium type. They have the automatic exposure facility and a thyristor, the effect of which is to speed up the recharge time and conserve the battery power as economically as possible. I like to hold the head away from the camera using a stretchy contact cable between flash head and camera.

I also have a tiny Sunpak which I have in my pocket with a one foot extension cable. This works off four little pen cells and is extremely useful for flash fill-in at weddings and fairly close-up informal party shots.

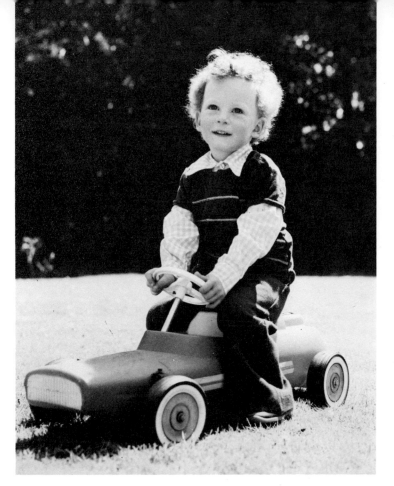

Typical sun spotlight on the back of head and body. I used a low angle to keep the head against out-of-focus dark foliage. Fill from reflection off the lawn. I also used a standard Rollei. This is a good subject to practise on.

Many 35 mm cameras have a hot shoe into which you plug a flash and fire away 'automatically'. The trouble is that it gives very flat lighting in close-ups and sometimes those terrible red lights in the eyes (red eye) in colour pictures. Also, automatic flashes and, for that matter the automatic printing machines at developing and processing laboratories, find it very difficult to expose for a person in the middle of a room taken with auto flash. Because the background is so far away the face becomes overexposed in the taking or underexposed in the printing. One way round this problem is to avoid shooting people or groups there and organise the picture against a plain light wall where possible. When shooting black and white however, it is easy to compensate while printing in your own darkroom. There are so many different flash units on the market that I cannot go into any details about individual models. The main guidelines are that 'You get what you pay for' so that the more expensive ones usually have greater light output include thyristors, and have quick 'recycling' times. On the other hand some of the bigger

units have so many extra accessories and 'features' that they may be too complicated and bulky for what you want. I like to keep my equipment as simple as possible.

Other accessories

A tripod is something every photographer should own. He will need it more often than he thinks. It should be light, strong and sturdy. I also am amazed at the number of amateurs I see around with beautiful expensive cameras and no lens hood. They are essential for standard and longer lenses, but not very effective with wide angles. I take many of my outdoor pictures into the sun or against the light and without a lens hood I would get bad flare, either from the sun or strong light hitting the lens itself.

Separate exposure meters are fast becoming redundant, with most new cameras being automatic or including built-in metering. (The studio flash units have their own special flash meters.) But when in doubt about your results read the exposure instructions in the film packet.

I find very little need for filters. The only one I use often is an ultraviolet or 'haze' filter for taking the blue tinge out of colour shots by the sea or in the mountains. My rule is the fewer accessories the better.

5

Film and Processing

The rule for this is rather the same as for cameras. *Pick your favourites and stick to them*. I found, years ago, that Tri-X was the best film for my kind of work. I discovered exactly what it could do for me and what I could do to it! For portraits and weddings I rate it at 200 ASA and slightly underdevelop.

If I ever need a faster, more contrasty black-and-white film I use, yes, Tri-X and rate it at 600 ASA by developing it for 2–3 minutes more. I can underexpose or overexpose it by two stops either way and still get an acceptable print. There can be a slight mistake in temperatures or developing time in the darkroom and it will still get me out of trouble. I have never found the grain any problem on the 120 size but one cannot take such liberties with the 35 mm spools. I need fast shutter speeds for most of my work and even if I don't, it is nice to be able to close down those two extra stops if I want to. Fine art and still-life photographers would probably use slower films but, of course, they can use slow shutter speeds all the time.

Although I mention Vericolor, which most professionals use for 100 ASA colour negative film, it may be difficult for the amateur to obtain so choose Kodacolor II or some other 100 ASA film.

Colour negative film

It is in this area that most progress has been made in the last few years. Kodak and two Japanese firms (Sakura and Fuji) have produced 400 ASA colour negative materials at the time of writing. Kodacolor 400 should be the ideal wedding photographer's film. It is brighter, sharper, more contrasty and two stops faster than Vericolor II. But you have to be very careful if you are caught with such a film in your camera and the sun comes out in full, no-cloud conditions. Accurate flash fill-in is the only answer but Vericolor II is better for full sunshine, being a less contrasty emulsion. I now use Kodacolor 400 for dull days and interiors of churches and Vericolor II as

soon as there is plenty of bright light, and with studio flash set-ups.

Colour transparency films

With all these the exposure has to be accurate to half a stop under, for the best results. 'Trannies' are for projecting and plate or block making for publication. I feel that pictures intended for printing as enlargements should be shot on negative film, no matter how good Cibachrome and some of the other processes might be. I like Kodachrome 64 for general use. I shoot virtually all my 35 mm transparencies for projection on it, and I also use it for copying. When asked for 120 size transparencies for commercial portraits of businessmen for reproduction, I use Ektachrome 64. Equally, one should not shoot pictures for reproduction on colour negative film, so that the plate or block has to be made from a colour glossy print. It is quite possible but not so cheap or easy, so editors tend to shy away from having to use prints, unless the picture is just what they want. As you can see, I use Kodak for my film, mainly because I like to get all my supplies from one reliable source. I am not saying that they are better than all others. That is a matter of personal opinion, because all the products of the major companies are of a very high standard. The answer is to find the film you know and like and stick to it until something better comes along.

Processing

I have never believed that the photographer has to do every process himself for the result to be genuinely his photograph. He should know what he wants to achieve in the final print or transparency and use the best method to get it, even if it means having a skilled printer, a machine, a laboratory, staff, whoever or whatever. I don't have any idea how to process or print colour, and I don't wish to. A good colour laboratory does a far better job

than I ever could, and much cheaper. I would rather leave it to the experts, send it back to them if it is not right and get on with the shooting. Even in black and white, where I do know all the processes, I would rather train someone else up to do it for me, with the possible exception of some interesting or difficult enlarging.

I suggest that beginners who really want to become good photographers *do* learn to do their own black-and-white developing, printing and enlarging. But, unless they are darkroom technique enthusiasts, they should leave the colour to the laboratories, using a cheap developing and printing service for family snaps and a better quality laboratory for serious work.

One other tip particularly for budding professionals— The labs have two types of service, machine printing (sometimes called economy service) and hand printing. Most machine printing is limited in the amount of cropping that can be done but the colour quality is usually just as good as a hand print, if the negative provided is up to standard. Since the machine service is much cheaper than hand, it is worth making a big effort to shoot accurately, both with exposure and in lining up the subject particularly avoiding camera tilt, for which the machine cannot compensate.

6

Where to Start (and Learning Quickly)

To introduce this subject let me tell you two true 'cautionary tales'. The phone rang and a man said 'Do you run courses for beginners?' I said, 'Not really. I expect people to know how to use their various cameras, so when they come on a course I can concentrate on subject matter, lighting etc.' 'Oh dear' he said, 'My problem is that I have bought a super Olympus outfit. I can work it quite well on the completely automatic setting but I sometimes want to use it the other way and I don't understand all these funny numbers with f in front of them which I think are called apertures and shutter speeds. Don't you run a course to explain them?' I suggested he bought a couple of books for beginners and came on a course later!

The second tale is of a Maltese restaurant manger who was on one of my courses. He had been sold a Pentax automatic, aperture priority camera with a macro zoom lens and motor drive, by a good salesman. Each time he pressed the shutter he finished a film! There was no manual override except for two stops either way, which he did not understand. He had bought a selection of slow films and was shooting machine gun fashion, at everything in sight, without the slightest idea what he was doing. He started taking pictures of me out of doors when I was standing in the sun against deep shadow. I asked him what shutter speed was showing up in his sights. He said 'One eighth of a second.' Nobody can handhold a tele lens at that speed. In fact it worked out that the correct setting for his picture of my face was 1/250 sec at $f5.6$, but his auto was reading the dark shadow area behind me. Now there is nothing wrong with that camera outfit in the hands of someone who knows what he is doing. But for a beginner it was futile.

The moral of these stories is quite simply 'Don't run before you can walk'. Just because the camera is expensive, it does not mean that you will take better pictures, unless you know how to work it. The average amateur family snap photographer will probably get far better results using an Instamatic, a pocket 110, or a simple

Learn to use your camera properly before attempting to take serious pictures. This photographer is looking through his from the wrong end!

38

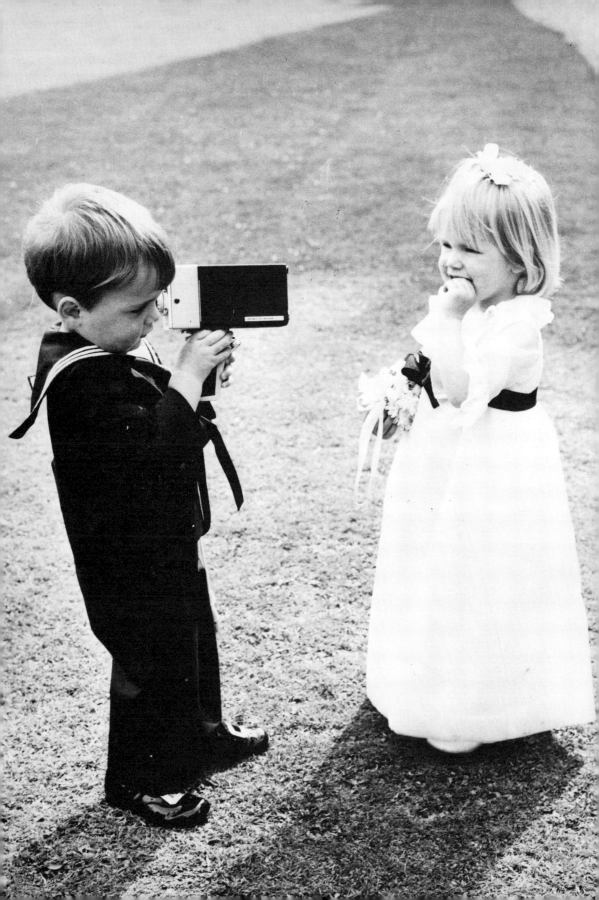

cheap automatic, than he will from an expensive camera. After a while you will find that a cheaper camera will not do everything you want and you should think about moving on to a camera with a better lens and choice of shutter speeds. This type of camera will need more skill to work, but it is a skill which most people can pick up very quickly if they really want to. Shutter speeds and f numbers sound very complicated to begin with, but once you get the knack, you will have no problem.

There are many good books for beginners and the instruction books of most cameras also carry simple information on the subject. Following the leaflets included in every film packet, gives a very good guide to exposures.

Fast learning

When my wife became interested enough in photography to want to understand shutter speeds and apertures, and why $f22$ let in less light than $f5.6$ and what the difference was between 1/500 and 1/15 sec, I hit on an idea, which you could use to teach or to learn. I opened up the back of an empty Rolleiflex which has a Compur shutter which is easier for explaining than a focal plane. First I put the shutter on B or time exposure and set the aperture at $f22$. I showed her through the back that $f22$ was a small hole. As I progressed through $f16$, $f11$, $f8$, $f5.6$, $f4$, $f2.8$, each move let twice as much light in as the previous one. Then, leaving the aperture at $f2.8$ I set the shutter speeds for 1/500 sec and then progressively 1/250, 1/125, 1/60, 1/30, 1/15, 1/8, 1/4, 1/2, 1 sec, explaining that each shutter speed as they went slower let in twice as much light. It was then easy for her to see that if the camera was set on 1/60 at $f11$, the shutter speed could be decreased to 1/125 and the aperture increased to $f8$ and still produce the same amount of light onto the film, since the first move halved the exposure and the second doubled it!

After this is mastered, it is not too difficult to learn or teach the basics of depth of field at different apertures, suitable shutter speeds for different focal lengths of lens

and subject (or photographer) movement, use of an exposure meter, different film speeds and ASA numbers. You would be surpirsed how many times I have asked people with good cameras what film they have loaded, and I get the reply 'colour film'.

There are a few basic rules for photographing people.
1 Don't use a shutter speed slower than 1/60 sec, even with the camera on a tripod, and where possible use a faster one.
2 Always choose a faster rather than slower film where possible.
3 Avoid apertures wider than $f5.6$ and use $f8$ and $f11$ or even $f16$ where possible.
4 Learn to use your camera quickly and efficiently before attempting important pictures of people.

Practising with a new camera

Let us assume you have bought a new (or even your first camera) and you understand the basics of photography. The first thing to do is to put two or three test reels through, waiting for the results between reels and keeping some sort of notes about the settings and the meter readings given for each shot.

When I test a new camera and want to practise focusing and using the metering system quickly, I usually load up with a reel of Kodachrome 64 and take the camera out into the garden. A colour transparency film tells you very accurately whether you are under- or overexposing, and projecting the slides tells you if you have focused accurately, held the camera still, picked the right aperture for the depth of field you need, or whether you have not!

It is sometimes difficult to tell whether a negative film is over- or underexposed, but it is much more obvious on colour transparency; even marginal overexposure here 'washes out' the colour considerably. With underexposure, on the other hand, the image is darker and the colour more heavily 'saturated'. In the garden, I shoot a variety of subjects from close-ups of flowers to long shots of the

house. I try a variety of exposures by taking subjects in the shade and full sun with, and against, the light.

If this reel is successful, I try some action pictures of boats on the river, the traffic in the local town, close-ups of dogs and a few candids of people in the street. If this one is satisfactory, I go on to shoot pictures of my children, friends or family—anybody with whom it does not matter if the pictures are not perfect first time.

If a beginner uses these three stages and does not move on to the next stage before getting good results, he can quickly train himself, to use his camera. Obviously all these stages can be done with the type of film of his choice. I would suggest he stays with one film right through ie: black and white, colour transparency or colour negative. Swapping around with types and film speeds just causes confusion. When he does move from one to another he should start at the beginning again. I do!

Self-assignments

As his confidence in his ability to handle his equipment rises, a photographer should set himself projects or 'assignments'. There is no success without something to aim for. Since the next stage is to become skilful at candid shots of people, self-assignments such as covering a school sports day, a garden fete, a yachting regatta, a motor rally, a children's party, a street market, high street shopping or even poverty in dockland would all be good.

At this point criticism is very useful, but nobody should expect it all to be good or even expect 'experts' to agree! The obvious place to look for unbiased criticism is at the local camera club. People love being asked their opinion. You will not always agree with them but listen closest to the person whose work you admire most. There is not much point in asking a still-life expert to judge portraiture except for technical quality! It is always worth telling the person you ask advice for what you were trying to achieve whether it was the atmosphere of a car rally

or just a sharp good quality print of anything. It is no good, as I know from experience, just handing a bundle of muddled, different sized prints to somebody and saying, 'What do you think of them?'.

Some people like to stay with candid photography and photojournalism all their lives—and very successfully too. There is a school of thought which believes that people should never be organised or posed, but should be caught 'naturally' in their surroundings. This is *not* one of my beliefs. There are a lot of shy people about, who find it difficult to 'direct' other people. They get tongue tied and nervous if they have to ask a model to 'Sit up straight' or 'Look this way'. At their clubs they hide in 'group' sessions, often shooting from all the wrong angles.

Shyness and nerves have to be conquered by anyone who wants to become a portrait or wedding photographer. I read one article on wedding photography in which it

The ideal subject for trying out a new camera—our daughter, Georgina!

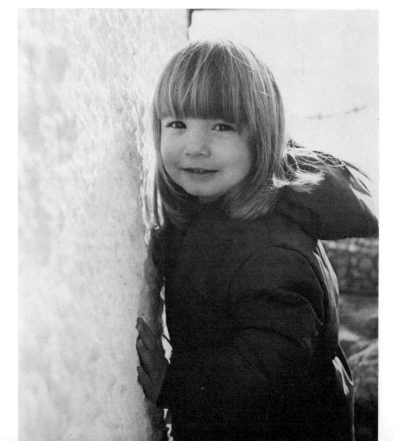

said that the main skill of this profession was that of a crowd controller!

The way to beat this barrier is to start by photographing family, patient friends and children to build your own confidence to give directions. The main reason I keep saying that you must be technically efficient and quick with your camera is that, when you start shooting your first subjects, you must be able to spend most of your time talking to them organising how they sit or look, and putting them at ease. If you have to worry about exposures for hours or fiddle with your equipment, they will lose any confidence they ever had in you, get bored and want to go home—but more of this later.

At this stage it might help you to enter competitions, take correspondence courses, read more advanced books or attend a one day or weekend course. I repeat one warning. You will not learn a lot from large group sessions with one model, except for watching the demonstrations by lecturers or experienced operators. You need to shoot the model by yourself to achieve anything.

7

Candid and Travel Photography

They say that travel broadens the mind but for many it also broadens the scope of their photography. Walking up and down your own locality does not make you want to reach for a camera. Although the subjects are there, as any foreign tourist will tell you, but they seem to you so ordinary and everyday that they are not worth taking. It is also difficult to make them interesting to your friends and neighbours because to them too, they will seem boring. This is why I suggested processions, carnivals etc. for practising candid photography. In fact, anywhere outside your normal environment will do.

When as I said earlier, I started taking pictures in Malaya, my aim was to keep a photographic record of what was bound to be the experience of a lifetime and also to take pictures to illustrate my letters home. It was a form of amateur photojournalism. Although the headquarters and military camps were Westernised, as soon as one ventured forth into the villages, towns, cities and jungles, it became another world, full of exciting sounds, smells, colours, architecture, atmosphere and, above all, people of all oriental races but mainly Malays, Indians and Chinese. There were crowded streets filled with stalls selling everything from a three course meal to an evening dress. There were the Tamil tappers in the rubber plantations. There were the naked children running around the rush mat huts in the outlying villages. So many, many pictures to take. I seldom took pictures without people in them. The people surrounded by their environment was what I wanted. Occasional close-ups of particularly interesting faces appeared in my albums but I had a relatively simple camera (a Zeiss Ikonta M).

My army friends featured as a record but my best set of pictures of them was when I took my camera on a long patrol into the jungle, when we had to fly into a clearing by helicopter. The others on the patrol appreciated this photographic record of life in the jungle and bought enough copies off me afterwards to pay my drink bill for a month!

There was one event which would have made a good

45

picture but which I could not take! Because of my excessive height (6 ft 3 in) and slim build I always looked ridiculous in any uniform, which seemed to be designed for small squat men. During a period when the whole battalion was taken out of the jungle operations for a period of 'retraining' at base camp, the senior officers thought it would be a good idea to have a physical fitness competition.

To show that the junior officers were just as fit as the men (we were not!) they were ordered to take part as well. One event was for us all to pair off against somebody our own height, then one to carry the other to the end of the football pitch in a fireman's lift, change over and race back. I came up against a corporal of my own height but he must have been 5 stone (70 lb) heavier. We took one look at each other and the corporal said 'I think I had better carry you first, sir.' I said 'Carry on, corporal'. He picked me up like a feather and ran to the other end well ahead of anybody else. I looked like a limp asparagus spear draped over his shoulders! He put me down and we both realised that if I tried to pick him up I would probably sink into the football pitch never to be found again! He said 'Sir, I think I had better carry you back again'. I said, 'Carry on, corporal'. He did and we won!

Sometimes pictures can tell a whole story. 'Horrors of War', 'Poverty in India', 'Hunger in Biafra' are all that is needed to tell the viewer where the pictures are taken and why. What I really dislike to see is a good descriptive picture saddled with a corny title which has nothing to do with the picture and merely makes it into a cartoon. Look at any amateur photographic competition or exhibition and you will see what I mean. When I am judging they never win! Candid pictures can sometimes be very funny in their own right, but are not helped by a trite caption.

This shot was taken in Malaya when I had just bought my first decent camera, a Zeiss Ikonta M; and it is still one of my best pictures ever.

It is very difficult to teach this type of photography. The photographer needs to develop good powers of observation, an eye for a picture and a sense of humour. Candid does not automatically mean the use of tele lenses.

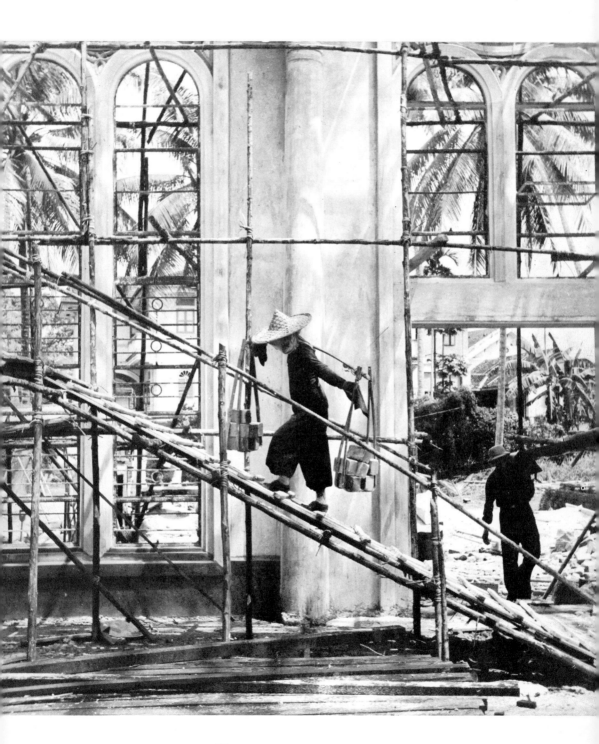

It is often more fun to shoot them with a standard lens! Many professionals use tricks, such as prefocusing by guessing, pretending to shoot something else and swinging round at the last moment, shooting and moving on, so that the subject cannot be sure if they were taken or not. I find that most people do not notice things above or below the level of their eyes. Thus, when shooting some movie film at Monte Carlo beach club of some of the attractive, funny and grotesque characters, I lay on my tummy pretending to sunbathe and nobody noticed me. Equally, walking along a promenade above a beach, I

Travel photography. My earliest attempts at this here in Malaya in 1954 during my National Service.

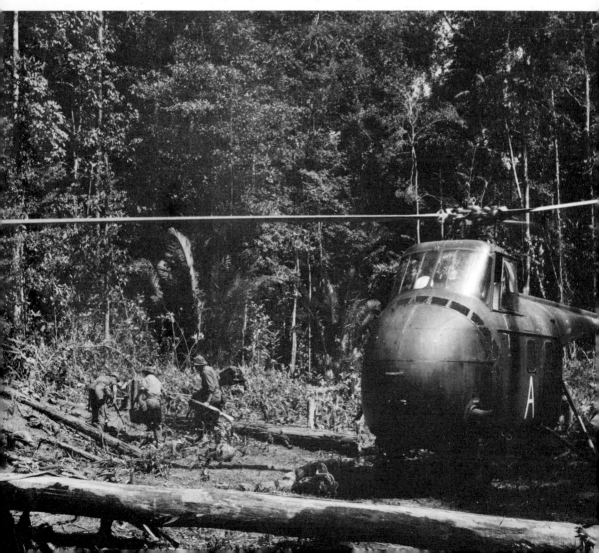

shoot down to catch the sun worshipers. The trouble with a tele lens is that everybody immediately recognises it as a 'spy' machine, on the other hand a black Canon F11 looks much the same as any other 'snap' camera to non-photographers! Even the most inexperienced family family photographer would improve his album pictures if he mixed his 'Aunt Flossie and Uncle Fred before the breakwater at Brighton' shots with some candids of them snoozing in their deck chairs!

In general, it is best to be as unobtrusive as possible and blend into the background. If you are dressed the same

Candid photography. Gatecrasher being thrown in to a pool at the Hurlingham Club during a deb dance, in 1959. Parties provide good candid pictures.

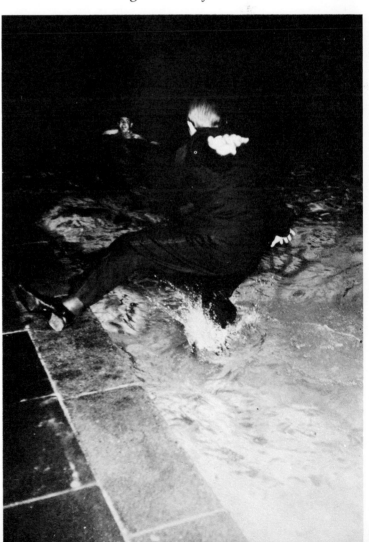

way as the other people around, no one will think you a serious photographer, unless you have a battery of battered Nikons with different lenses round your neck.

When my wife and I went on a winter holiday to Morocco, we were asked at passport control what sort of photographers we were, because my passport lists that as my profession. I quickly said 'studio portrait' because they don't take kindly to journalists. Some of the locals don't mind their pictures being taken but for others it is against their religion. (They think the camera steals their soul.) One must respect this and, if anyone waves their hands or turns away, don't shoot. Again you are much more likely to be spotted and shouted at if you are standing in full sunshine in the middle of the street, instead of sitting quietly sipping tea at a pavement cafe in the shade. I once had oranges thrown at me when I ventured too deep into the fruit market of the casbah. I also found that nobody took any notice of me when I was with a conducted tour, although it was sometimes hard to avoid the other 'trippers' unless I was ahead of—or behind the party. I found I could also shoot a lot of pictures unnoticed from a car window.

Travel pictures are by no means always candid. Close-ups of Red Indian chiefs, Indian guru, fishermen or any local character can be taken as outdoor portraits in full sunlight. Equally, wide angle shots of a town from a hill, aeroplane or high building, set the scene for pictures with atmosphere.

Free-trip photography

My biggest-ever travel commission, was to record the first jet service round the world. I got the free trip in rather a cheeky way! I saw the advertisement in which Qantas, the Australian airline, was advertising this new service. I knew that some journalists were being given free seats on 'inaugural' flights, so I rang the editor of *The Tatler*, which used to publish general features, and he said he was interested. I contacted the Qantas press

officer who said it was rather an unusual request, since seats were normally allotted to air correspondents or travel editors. However, they did have an artist from *Illustrated London News* on the list so she would check with head office in Sydney if I could get a guarantee from *The Tatler* to publish a number of pages on the story. The editor gave me a promise for a minimum of four pages, half on the trip and half on 'Social Sydney'. I had my free trip round the world, but felt I had to get as much coverage as possible for Qantas. I finished with nine pages in *The Tatler*, five in *The Sphere* (no longer published) and lots of other worldwide publicity.

My approach to the picture taking was to record how it felt and what one saw. On the way out it was virtually non-stop or, to be more accurate, no stop over. We set off from Heathrow in a Boeing 707 at about 11 am, stopped briefly for refuelling in Iceland and went on to New York. All I could shoot were people and characters in and just outside the airport there and in San Francisco. Night fell over the Pacific because we were chasing the sun. At Honolulu, as we reboarded, dawn was coming up over the mountains behind the Boeing, giving me one of my most spectacular shots. In Fiji the artist and I were taken out to a local village where we pictured the children and other Fijians quickly, before being whisked back on board to fly to Sydney where we arrived 36 hours after we set off from London. Exhausting is not the word. We were given one day's rest before being whizzed round Sydney, the Snowy Mountain hydroelectric scheme, Surfer's Paradise, Cooma, Coolangata and finally Melbourne. And I arrived dressed in a white dinner jacket for a Royal Ball (Princess Alexandra was there) and all the locals were wearing white tie and tails! It was a very cold spring there!

The only pictures I took on the trip which did not come out were some flash snaps of the prime minister, Sir Robert Menzies. My flash contact had slipped off 'electronic' so the pictures were not synchronised. I have seldom made that mistake since! Luckily none of my

clients at home knew I had taken him.

We could travel home with a stop over by any route. I chose to come the other way home by Super Constellation petrol engine with propellers at 275 mph, with stop overs in Singapore, Calcutta and Karachi plus refuelling stops at Jakarta, Athens, Rome and somewhere in Germany. At the stop overs the Qantas press people helped me to see as much as possible. So I brought home a huge selection of negatives. Qantas even put up an exhibition of my work in their offices.

To people who said where have you been for the last three weeks it was fun to be able to say 'Round the World!'. The only trouble was I caught a terrible cold in Karachi and arrived home feeling like death!

Since then I have been on a couple of trips to Beirut (courtesy Middle East Airlines) before the war with Israel and saw the fabulous ruins of Baalbek and Byblos, Kuwait, Jerusalem and the areas around. Again, the payment was in publicity for MEA and Lebanon itself, since MEA is the national airline of the country.

You might say that I was in a privileged position to have these trips, but anyone who could produce guaranteed results and press cuttings could have done it. I thought such trips had become harder to come by because publication of work is becoming much harder to achieve, but I read recently in a photographic magazine of how an amateur freelance has a virtually free working holiday in the USA every year. He had discovered that local papers love picture stories of local people working in unusual jobs or who have some success in show business in the USA, apart from straightforward travel reports.

He plans his trip and then writes to the Chamber of Commerce in each town or city saying when he expects to be there and that he will be writing and photographing for British newspapers. He is wined and dined in each place and given accommodation and all facilities to find his stories. When he gets home he makes a point in sending the cuttings to each host. All he pays for is a cheap return fare, a Greyhound bus ticket and the odd

meal. His publication fees cover these expenses plus a little extra and because of his good manners in sending results, he is always welcomed back the next time. I think he shows great initiative.

Before I married, I usually went abroad twice a year; once to the south of France and once for a fortnight skiing. I always took my camera along and made them 'business with pleasure' trips. It took me some years to be able to ski with a camera round my neck so during the early years I concentrated on shooting the social scene for *The Tatler* and general shots for the tourist offices in the resorts who subsidised my hotel bill. Later, when I did manage to teach myself the art of shooting action skiing pictures, they sold for many years through Colour Library International to travel brochures and publications throughout the world. (I took care to have a neutral background with no identifiying landmarks in these shots!) Equally snaps of the British girls working in the South of France, sold well to the newspapers. I could always show cuttings and receipts for the trips to the tax man who allowed all my travel as genuine travel expenses, except about £100 a year, against tax. I have talked a lot about making travel pay for itself, even if all the pictures one takes are not genuine travel photography, but it is becoming so expensive to move around the world, why not subsidise it?

8

Family and Friends

Although I have suggested that keen photographers should start practising on 'things', moving on to candids and travel before tackling organised pictures of people, most will already have shot family and holiday pictures. I did myself. Many will only have used the cheapest of cameras, but it may have awakened their interest in photography. For instance I gave my goddaughter, Annabelle Burges, an Instamatic when she was eight and, because of her continued interest and frustration with it, a Rollei 35 B (35 mm) when she was 18. People who have just done this should go back to p. 22.

There are two forms of family photography, the candid and the organised. I use both for my own pictures and commissioned work. I have to use organised pictures because candids often do not show the face or features, although they may be more 'natural' looking pictures. One cannot fill a family album with back views and profiles, however arty the pictures. The answer is to keep the organised pictures as natural as possible—informal instead of posed.

Backgrounds

These should be kept simple or 'in composition' aiding and not detracting from the main subject, be it one person or a group. *No* trees growing out of heads. *No* horizons cutting through heads. *Use* plain walls; green foliage (preferably out of focus); plain sky, even if it becomes necessary to shoot up walls for a full-length shot, grass or lawns, by shooting down for a head shot; water, sea, sand for the same thing. In other words, it is the people that count, not the background.

Lighting

Avoid harsh, high midday sun in open places. *Avoid* any sun that is shining into the subject's eyes and making them squint or screw their eyes up. *Don't* stand too far away from the subject—a common beginner's fault—but

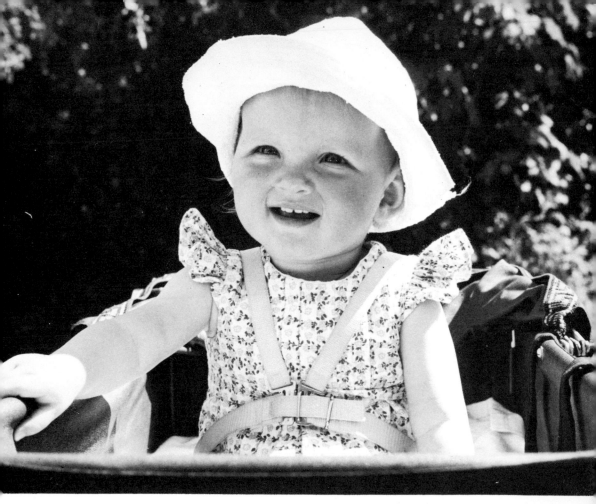

Face lit by reflection of sun off the white pram cover; the head is outlined against the dark background.

try and fill the frame of your camera leaving a little to spare all round. Avoid flash fill-in out of doors unless the contrast between light and shade is just too much. If used, keep it to half power. *Use* available reflectors such as light walls, as your main light and turn your sitter back to the sun—not forgetting to fix a lens hood onto your camera, in fact you should never take it off!.

Grandparents

Older people, more than anybody, dislike having their picture taken but most albums lack pictures of them and the families regret it when they die. If they have beautiful character faces, try and persuade them to let you take a few close-ups. Otherwise you will have to do some sneaky candid shots when they are doing something else such as playing with their grandchildren, doing a bit of gardening, going for a walk, snoozing in the garden or whatever.

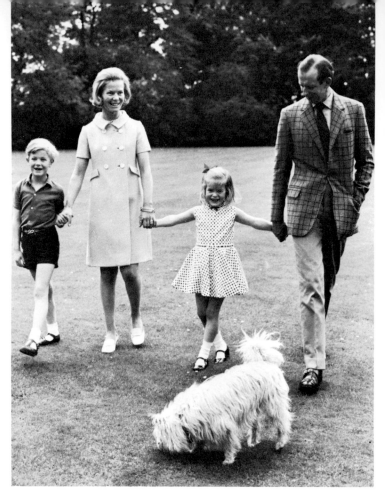

This photo of the Duke and Duchess of Kent with their two children, the Earl of Saint Andrews and Lady Helen Windsor, plus their dog, was taken in May 1969. It was widely published and I have used the 'walking group' idea ever since.

Groups

Sometime someone is going to ask for a family group, which is probably the most difficult of all pictures to take. If old people are included, they will probably have to be seated in a chair but the others can be grouped round keeping their heads at different levels. Above all *avoid* a row of people standing in a straight line, with all their heads at the same height. Luckily there are usually children of different ages. Some can sit on the ground, or on the arm of the chair or sofa, with maybe another perched on the back of the sofa, One of my favourite tricks with parents and children on a dry warm day (I prefer hazy sun conditions for all outdoor pictures of families) is to ask them to line up against a hedge at the side of a garden with the sun, at least not in their eyes, hold hands (to keep them in line) and walk towards me while I walk backwards, shooting them at roughly the same distance. Dogs can be included if necessary. I tell the younger members to tell me if I am going to fall into

the pond or hit a rose bush and they are all looking at me usually smiling, because I look so ridiculous. A fast shutter speed and accurate focusing are essential. If I do not have enough on the first run we repeat this exercise.

Expressions

It will never be a good picture if everybody looks dreary. Smiles in groups are the only thing that saves them from being deadly dull. How to get them? Jokes take too long. My trick here, even for royalty, is to ask them to say words but *never cheese*. The only people it does not work on are actors, actresses and models, because they think they know their best expressions anyway—and are usually wrong! What I do is to tell them I am going to say a series of words and all I want them to do is repeat them. I might start with 'Say biscuits.' 'Say Snoopy' after they get the idea I can drop the 'Say' and carry on with 'Bangers and Mash', 'Hamburgers', 'Muppets', 'Miss Piggy' and then I invent a few such as 'Whiskytickle', 'Grindlefartle'.

It is surprise that makes people laugh. If you think about it, that is why people laugh at the punch line of a joke. In fact I never tell 'jokes' always 'stories'. If you say 'I know a good joke' it can kill the tag line at the end because they are expecting to laugh and there is no surprise. Another reason for the series of words, is to hold everybody's attention. There is nothing worse than a group picture with some of the people looking in different direction, such as a mother looking down at a child. Keep talking. Keep their attention.

Weddings, Christenings, Parties

Apart from keeping well out of the way of the professional photographer, these are ideal events to catch the family looking their best and there are very often good opportunities for candids. Children are the subject of the next chapter.

Presentation

Most family albums are ruined by lack of editing out the really bad or repetitive pictures or by the lay-out of rows of same size prints. The best rule is—Slow up the good ones and cut out the bad ones. Even enprints and other small sizes can be helped enormously by trimming them into smaller and better composed pictures and arranging them carefully. The occasional super shot blown up to the full page of your album it will look stunning and make the album far more interesting. Always vary the lay-out and number of pictures on a page. A large pair of scissors can be used for trimming but a simple 'guillotine' or photographer's trimming knife can be bought at most photographic dealers.

Slides

Slide shows can be equally deadly boring. If you do like to give shows and chat about the pictures, edit cruelly and avoid repetition unless it is a deliberate sequence of pictures. Don't just select an unconnected series of images but try and get them into some order. Remember anecdotes where possible.

Mounting and Framing

There are frames to fit most standard sizes in photo shops and stationery departments of big stores, so there is usually little need for mounting. Also the light cardboard 'folders' are easily available and present a picture nicely for selling or giving away. Your photodealer will tell you what ways he has of mounting and, of course, there are professional framers and mounters.

Picture quality

When you take a badly over- or underexposed transparency it is best to throw it away because there is

nothing you can do about it. Black-and-white and colour negative has more tolerance for mistakes. If you do not understand what a good or bad negative looks like and are not happy with the prints you get back from that cheaper-than-cheap laboratory you have sent it to, either show it *and the negative* to an expert friend or your local dealer, and if he helps you, don't forget to take your next reel to be developed and printed through him!

9

Child Photography

Let us now hope that everyone reading is taking good efficient pictures with their chosen camera, and also through the practice obtained from shooting flowers, candids, holiday and travel shots. The family album should be an interesting well laid out book for all to see with beautiful, funny and interesting shots of family and friends. Let us move on to friends of friends and start with their children. This is what I did, and which helped me launch into my career. I realise not many people want to become professional, but enormous pleasure can be given by taking some super pictures of their children. Even if one only gets the acclaim of seeing one picture framed and signed on the piano or sideboard of a friend's house, one knows that one has given pleasure to that family.

Many children are very photogenic and usually easier to get on with than adults. In the old days, professional photographers usually took family pictures in a studio, or transported a studio set-up to people's homes for formal child portraiture. Some were, and still are, very good. Marcus Adams took amazing shots with a huge plate camera and long exposures. I will never know how he managed to get the children to stay still for several seconds. The local high street photographer usually shoots only in colour, using a blue or specially designed studio background which reproduces well. The trouble is that every sitting seems to resemble the last one and one photographer's work looks very much like another's. The advantage of this standardised lighting and background set-up is elimination of waste. Results are technically perfect every time. There is lack of originality, but the clients only want a good likeness of their children to frame or give away as Christmas presents. They do not mind the formal pose. In fact, they scrub them clean and put on their party outfits before they arrive at the studio. They judge the pictures by the expression of the children and how pretty they look. They do not notice the background and lighting. The subject matter, as usual, is all-important.

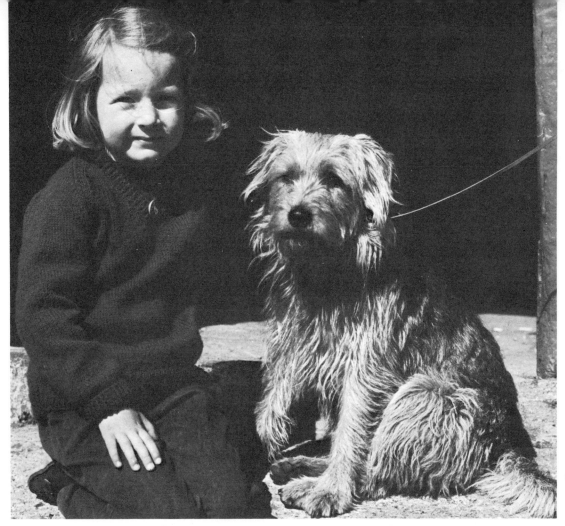

An open door gives a dark background. Main light from the sun was filled in with reflection off the gravel. The direct sun was a bit to strong for the child but ideal for the dog!

These studios provide a relatively cheap service for people who cannot take pictures themselves, and there is nothing wrong about that. The trend now is to persuade the clients to have the best one enlarged, (20 × 16 inches) and canvas-bonded to look like an oil painting and gilt framed. This makes the picture look very much more important and can be hung over the mantlepiece in the lounge. It works, brings extra profits to the photographer and most of the time delights the client. I personally don't like it. Enlarge and frame a photograph by all means, but why try and make it look more important by forcing it to resemble an oil painting?

The amateur usually has far more chance to take natural, artistic pictures at home and out of doors. When I started taking pictures of children professionally, I began to get a name for shooting them, as far as possible, in their own surroundings, or out of doors. I visited one family where there were some pictures by a studio photographer on the

piano. I mentioned this to the mother, who said, 'Oh, he is famous for formal portraits and you are famous for 'cow-pat' pictures of children!'. I have been doing 'cow-pat' pictures ever since and only use electronic flash, when I am forced indoors or very occasionally for fill-in flash out of doors on a sunny day.

I am always in direct competition with the good amateur because I am trying to take super quality snapshots. I therefore have to take much better quality snaps or they will not pay me!

If an amateur can raise his standard of photography of children, there is a ready market for his pictures among the families who want good shots of their kids. His competition is the 'school photographer' who goes to the big schools (very often giving a 'commission' to the head-master to get in) shoots one or two of each child, is skilful enough to get one good expression, and puts the results in 'smart' folders. The child takes the picture home and, even if they do not particularly want them, they don't want to embarrass the child by saying 'Take it back, dear. We don't want a picture of you'.

The other competition comes from the type of young man who came on one of the weekend courses I ran at my home. He lives in Manchester and using a local map selects a different housing estate or area each week. He does not have a studio but he does have a car with his equipment in it. He then actually knocks on the doors of each street and offers families a free sitting of their children. If they don't like the pictures they don't have to buy them. When he gets colour machine prints back from the labs he offers them very cheaply to the parents. Ninety-nine percent buy the 'proofs' so he covers his costs all the time. The profit comes from the reorders and framed pictures later. It is a thought for those who are young, go ahead and want to be professionals. Whatever sort of child photography you want to do, it is best to start with the informal variety first, training yourself to handle your camera quickly and efficiently and learning how to direct the subjects.

'Scruff'. I could not resist this face, taken outside a church at a wedding. It did not sell, but I love it.

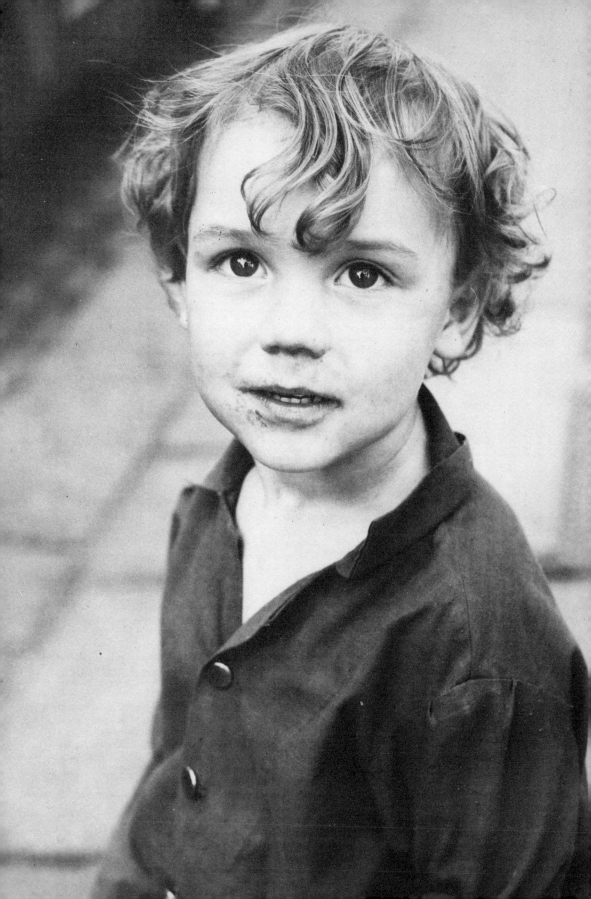

The marvellous thing about photographing children is that all you need to start is a good camera and a portable flash for indoor shots. A single-lens reflex 35 mm camera with a standard lens will be fine. Through-the-lens metering helps.

I use a standard Rollei lens for most pictures because I like the $2\frac{1}{4}$ sq in. format which gives me extra quality, fast focusing and a larger negative to play with. Longer lenses are only needed for close-ups of small faces. I was recently asked to do a passport picture for a baby only 10 days old. I needed a microscope(!) but my Tele Rollei with close-up lenses worked well. For the older children I don't want to be laden with extra lenses, tripods, reflectors and meters when chasing a two-year-old round the garden.

Before I married Mari and we had any children (the first arrived when I was 40), I refused to take babies under nine months except at christenings. I felt they were too small for the pictures to last and be worth my fee. Also I was not confident of good results. Now I have a son and daughter, who I have photographed from a few hours old, I will take on anything!

Lighting

Outdoors in daylight is best. Cloudy bright or hazy sun conditions are ideal. With the sun out shoot 'into' it and be sure to have a reflector like a light-coloured wall, a light rug on the lawn for a baby, a light house behind you or even dried up grass. These can reflect enough light onto the face without making the subjects screw up their eyes. Keep the backgrounds plain as for family pictures. Use only flash fill-in (half power) in extreme cases, not as a rule, to play safe.

Indoors, unless there is sufficient light from the window I have to use electronic flash, either portable (Metz 402) or a Bowens Monolite with highly reflective white brolly. The short duration of the flash in effect, arrests the movement of children, who never actually seem to stop moving.

I like children to wear everyday clothes for some of the pictures in a sitting.

64

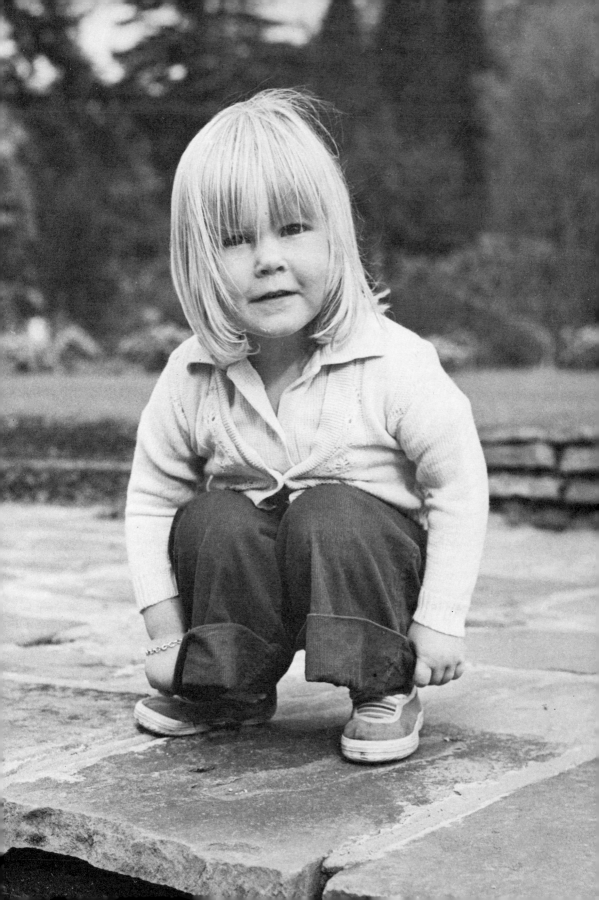

When using the Metz, which is computerised for exposure, I just set the camera on 1/250 sec at ƒ8 and the flash on ƒ8 and let the automatic wizardry of the machine sort out the exposure. All I have to think about is focusing, framing the picture on the camera screen and directing the child. These flash guns often give better lighting if held away from the camera, or aimed at a light wall or low ceiling for soft reflected illumination. If you use this 'bounced flash' be sure you have worked out how to adjust the exposure accordingly. It really only works in a small light-coloured room with the flash on full power and manual, *not* automatic, using an aperture of ƒ4 or ƒ5.6. Automatic flash is only successful in these circumstances if the 'magic eye' sensor is fixed to the camera or very close to it in other words separated from the flash source.

When I took a set of pictures of Lord Nicholas Windsor

Bounced flash is best only when used in small light rooms, such as a bathroom.

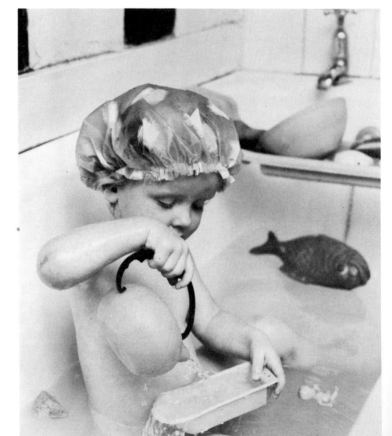

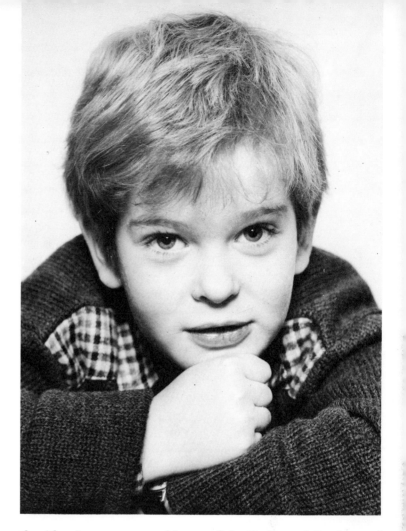

Lord Nicholas Windsor, younger son of the Duke and Duchess of Kent. There was no way to take him outdoors, so I used one studio flash with a large brolly.

the (then) seven-year old son of the Duke and Duchess of Kent, it was a semi-secret session! The Duchess wanted to give them as Christmas presents to the Duke and other members of her family. I was asked to be as quick and discrete as possible taking very informal pictures. In other words I could not move in my whole studio! I decided on one large portable flash unit with white brolly. It had to be done after school in November so there was no hope of any outdoor shots. The Duchess showed me the rooms available and I chose his 'nursery' which had white walls and plain furniture. Nicholas was very interested in the cameras and flash so I explained how I worked them, letting him look through the viewfinder of the Rollei and take readings with the flash meter. We cleared one wall to make a plain background and I set up the flash with brolly in the opposite corner of the small room. This reflected a lot of light onto the walls as well as giving some modelling to the face. Also, anywhere

I took a reading in the space which Nicholas would occupy the exposure was always ƒ11 on Tri-X—very useful if you want to move your subject about. The Duchess had asked me if I wanted her to stay or slip away. I asked her be in the house but not in the room, so Nicholas and I had great fun for an hour trying different ideas. Some with him resting his arms on the back of a small sofa with his fist to his face, some on his tummy lying on the floor, some at the piano and some reading a newspaper. Her Royal Highness liked the pictures so much she asked me back to do some of The Earl of Saint Andrews, their elder teenage son. Not such an easy age but we got some nice pictures. Unfortunately, since Nicholas' session was for private family pictures, and there was no reason to release them to the press, I was not allowed to give them to the newspapers but I can use them as examples of my work to illustrate this book! The first session when I took pictures of the whole family did get world release, because they were going on a foreign tour. Thus the royal advisers work!

Back to some more practical advice! You will have noticed that I used Tri-X even with a powerful flash unit. My system is to stay with the faster film, because I often need the extra depth of field when focusing or a fast shutter speed out of doors. Don't worry about grain. It is the subject matter that counts. Tri-X or HP5 for black-and-white, Kodacolor 11 or 400 (if you need the extra speed) or Vericolor II the professionals Kodak film, if you can get it for colour negatives, and Kodachrome 64 for transparencies on 35 mm, otherwise Ektachrome for 120—these are the films I use for virtually everything.

The beach is the ideal place for informal and candid pictures. With or without sun, there is usually nice bright soft light. This can be blue on colour film because of the UV light which the eye cannot see but the film can and does. Leave a UV or haze filter on all the time to be safe and protect your lens from the spray.

Indoors the light from a big window is useful for child-

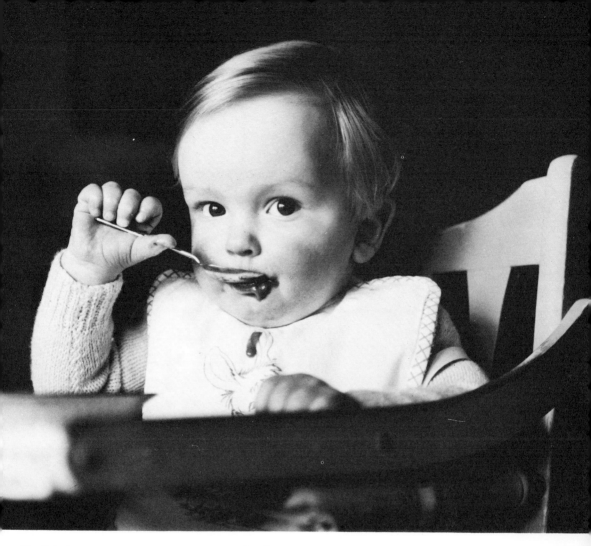

The light from a window was all that was needed for this picture.

ren who have reached an age where you can persuade them to sit or stand or play where you want them to. With a smaller child it might be better to use a different approach such as 'What can you see out of the window?'.

Backgrounds and props

There is no need for specially painted or organised backgrounds. But indoors, try and pick a plain wall. A window covered with net curtains might look good but, sure as anything, your flash will reflect in the glass and come straight back into your picture, ruining it. Even out-of-focus patterned wallpaper looks very odd, and it is obviously best to avoid a lamp standard or vase growing out of the child's head.

Props should be in the same focus 'plane' as the child. Get the child to sit on a garden swing, kneeling or sitting

on a bench, standing at the top of a garden slide, leaning out of a car window, which makes a good frame for the head, shoulders and even arms and hands. 'Riding' a bike or sitting on a pony, gives them something to do with their hands.

With babies don't introduce a large toy into the picture or it will overpower the child—a bunch of keys either rattled over the photographer's head or even in the child's hands is quite big enough and often successful.

I have a toy furry animal who appears on TV and whose voice I can impersonate a little. 'Basil' takes the pictures from under my arm. At a wedding where I had a fair number of small attendants, I borrowed a toy Snoopy, put him down my jacket so that the children could not keep their eyes off him. Later, my left hand held Snoopy who 'crawled' over my shoulder while I was saying 'Where has Snoopy gone?' while taking pictures and winding on with my right hand. (The camera was on a tripod.)

It pays to be inventive with children. Even if Marcus Adams used the same tricks, years ago, he did not tell us about them!

I think it is worth repeating here that one must be fully prepared for a sitting. When I turn up 'cold' to a family, I don't need them to be ready and waiting for me. I like a little time to discuss what they will wear, give the mother the idea, tactfully, that where possible I like to work alone with her offspring, and take a good look around for the best backgrounds and locations for light. One child at a time is no problem. It is the groups that are difficult. With all this preparation I also work out probable exposures in various parts of the garden, both with and without sun, if it is one of those 'in and out' days.

Age groups

The problems vary as the child grows up. Babies are most difficult when they are tiny, but the child aged 10 days, for whom I had to do some passport pictures did eventually

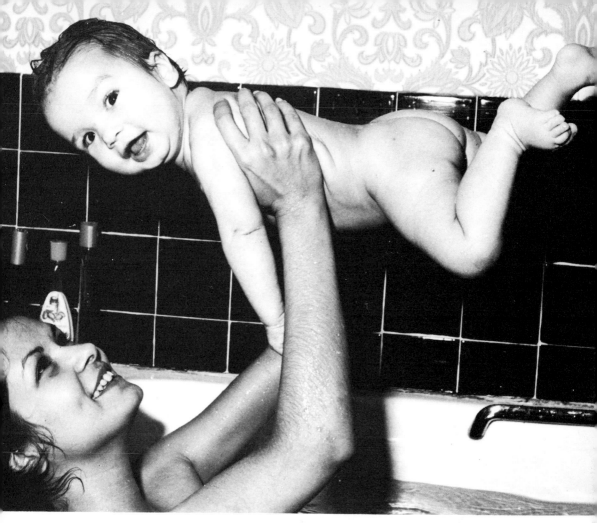

This shot was published first in *The Daily Mirror* and was taken with a Canon F1, with automatic National flash on camera. The 'magic eye' worked out the exposure for use.

'wake-up'. With a Tele Rollei and close-up lenses I got some adequate head and shoulders shots and, in the dark-room, enlarged only the head for the passport. I tried two ways of placing the baby, remembering a plain light background was needed. I first tried the mother holding the baby upright with a shawl draped over the mother's shoulders and waist to make the background. I was using a studio flash with soft white brolly, which does not hurt their eyes. Not much luck there. Secondly I spread the shawl on the floor, placing the baby with her head towards the light. When she did wake up she turned her head either left or right, mostly right. I positioned myself that side and took pictures when she opened her eyes. In the darkroom I turned the prints so that instead of lying on her side she looked as if she were sitting up. I could have taken them from overhead but there is always a risk in handling heavy equipment directly over a tiny child.

71

3–4 months

This is the age when most strong babies begin to 'prop up' on their arms for short spaces of time. This can be helped by shooting them on the floor with some plain cushions for them to prop up on. It raises their heads higher and if you are flat on your stomach on the floor with the lights about three feet above you, you have a grown-up looking picture of a child. It is worth remembering that most baby pictures are taken of the whole baby. It takes more skill to get a close-up of their face and even many professionals do not attempt it, but parents are amazed and love it. With both of my own children I took pictures on the first day with a Canon F1 from a distance of 18 inches by the light of the hospital window. Naturally their eyes were not open but it was a record for the Hustler family album!

Mother and child

Possibly more difficult than tinies! Mother is always worried about what the child is looking like and forgets herself.

You may have seen Lord Snowdon's pictures of Princess Anne with young Master Peter Phillips (and some with dad) for the Princess's 28th birthday. She was beautifully made up and her hair nicely arranged for the pictures. I expect she discussed with Tony what to wear and, since Tony wanted soft, natural-looking pictures they settled for white for the baby and a Victorian style high-necked long-sleeved dress for Anne also in white. In most of the pictures the mother had her hands carefully placed holding Peter (then 9 months which is a good age for the first important pictures) from behind his back. There were one or two I saw where her hands had crept round as if holding him up. Here hands were rather a large part of the picture but the expressions were so good and natural that it did not matter. Father's legs and feet (they were sitting on the grass by a lake) were hidden and

The little girl fell over when we were walking across a field. This was a good chance to take an unusual angle and 'pose'.

72

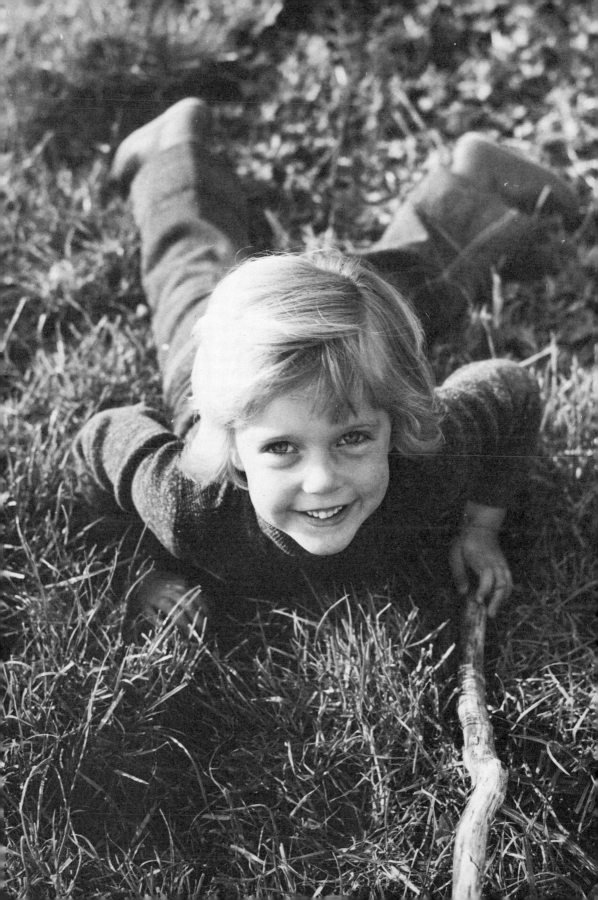

Mother's were covered by her long dress. All together very nicely worked out. If one does not learn by analysing other peoples work, what will you ever learn?

1–2 years

When babies approach two years, they will probably be crawling or toddling, in other words always on the move. They may understand simple words but it all has to be a great game. You cannot ask them to do anything so you either have to follow them round, anticipating what they are going to do, or place them in a situation and wait until they do something phtogenic. A toy car, playpen, or high chair might 'anchor' them for a little while, but always be ready with some new idea.

2–6 years

Children between 2 and 6 years are probably the easiest of all. They are usually very natural and will co-operate with you if you can get through to them. They will often 'show you the garden', look at a book, play grown-up games reading daddy's newspaper. (I had one child who tore up daddy's favourite magazine, which was not very popular!)

Older children

As children get older, they become more self-conscious, and therefore more difficult to photograph. This is where the technique of asking them to say different words starts being useful. Any word they recognise but are not expecting will do, as for family and wedding groups. 'Baked Beans', 'Muppets', 'Whisky', anything that comes into your head will do. It really works. Always hold a conversation with them and tell them what you are doing and what each gadget is for. Always try and treat a child as a grown-up little person. Never talk down to them. If you are tall, sit on the floor, when you are getting to know them, and dress informally.

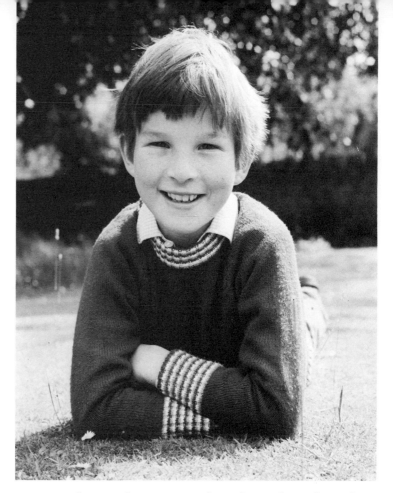

Lying on his tummy on the reflective dry lawn is a good pose for an older boy.

Try and treat them as equals and get through to their minds and personalities. They will appreciate it. Ask the questions and make their minds work. It will also take their minds off being photographed. Observe their reactions then photograph them!

General points

I was asked recently on a radio show whether photographers had to be psychologists as well. I said I thought it was true to a certain extent but observation plays a large part in it. The amateur or family photographer has much more chance to pick his moments than we poor professionals, who only have an hour or so to get to know the children and take super pictures. Father can get his camera out on a fine sunny day when the kids are playing in the sand pit or paddling pool, washing the car, hosing the flowers, having a bath or whatever. We may want to do this but it could be pouring with rain when we arrive so have to be prepared for anything.

How many to shoot per session?

Many people have the idea that professionals shoot hundreds of pictures leaving it to luck that some will be good. This may be true of bad fashion photographers, but it does not work that way for most of us. Some children are shy and take some time warming up so the last shots may be best. Some are interested straight away and the first reel is the most successful. With a sitting of one child I normally take about 36 pictures using six shots on each idea. With more than one child, plus family groups, I may have to take another 12 or more. If it is all colour I have to keep to the 36 or charge a lot more! I try and make every shot a good one and that gives me 6 or more very good ones.

Bribery

When I have a particularly difficult and shy child who does not want to be taken I occasionally resort to bribery. 'Would you like me to take one of teddy? Yes? Hold him on your lap then.' It just so happens little Bobby is in the picture too. Or I say 'If you let me take some of you, you can take one of mummy with my camera.' In the last resort the promise of a packet of sweets after we have finished can do the trick.

Teenagers

The poses have to be more formal for teenagers, so I tend towards head shots. Leaning over garden gates, car bonnets, with the bike and other ideas sometimes work but it is an awkward age.

Father and child

Everybody thinks of mother and child and fathers tend to shy away or be at work or on the golf course. But, if he

Don't forget father in the family
pictures if he is around!

is around, I usually try and include him in the shooting
somehow.

Child photography needs perseverance and patience.
If you don't like children don't try taking their pictures!

10

Indoor Portraiture

It may seem odd to talk about indoor before outdoor portraiture but, as you will see later, there is a point to it. Think of there being two sorts of lighting: a spotlight which gives a narrow beam and a sharp shadow; and a floodlight, from which light is transmitted from a large area therefore giving a softer light with an indistinct shadow.

When I first bought some lights for portraiture, they were small secondhand floods, used with photofloods (bright overrun photographic bulbs). They give a light which is somewhere between a spot and a flood. I had read a book illustrated with many of Cornel Lucas' movie star and starlet pictures of the 1950's, and this was the style I tried to copy. It was really the same lighting as was used in the films of the day. There was always a spot shining from above and directly in front of each character 'down his nose' giving a clearly defined nose shadow. There was another shining on the back of his head to outline it and separate it from the background and there must have been some weaker floods slightly filling in the shadows. It was a flattering if unnatural lighting. With the heavy soft focus diffusing screens over the lens it was very flattering for the ladies!

When I joined Dorothy Wilding I found that she did not use this method at all. She had her own style. She used a much more 'characterful' main light from more to the side and relied on retouching for flattery. This was done on negatives and prints. Her lighting set-up was two huge floods with 1500 watt bulbs in them and covered by a sort of fibreglass diffuser. One lamp was placed on each side of the camera. This gave a very flat, all-over light. Added to this there was a 'modelling light' which was a smaller flood with a photoflood in it, also screened with fibre glass. This gave the main light and shade to the face. Behind the sitter were three small spotlights. One was directly behind shining onto the background to give a soft, spotlight effect behind the sitter's head and the other two were the hair lights. When I took over DW's business I adapted her lighting more towards the Cornel

78

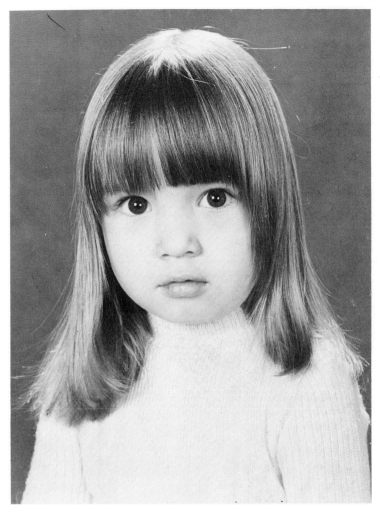

Georgina, our daughter, taken with my basic 'studio' lighting set-up. A main flash 'down the nose' and weaker studio flash filling-in the shadow the other side. A third flash shining from above the mini background with our 'curtain material' blue background hung from it.

Lucas style but not completely—a much softer version. DW was the master of the formal pose with the informal expression technique. Cornel was the master of the glamorous film star picture.

Lord Snowdon was recently quoted as saying. 'If you recognise who took a set of pictures by the "style", then that photographer has got into a rut.' I agree with him and don't think I have an obvious style, but DW, Lenare, Harlip, John French, Baron and many more all found quite profitable 'ruts'. Ruts were the fashion in those days and Tony successfully broke the rules and helped to lead this kind of photography out of the doldrums.

I do have a basic lighting set-up for portraiture, which I teach at my weekend courses and lectures, and use it as a 'kicking off point' for my sittings. The floods have turned into flash heads with a bowl reflector or a silver, gold or

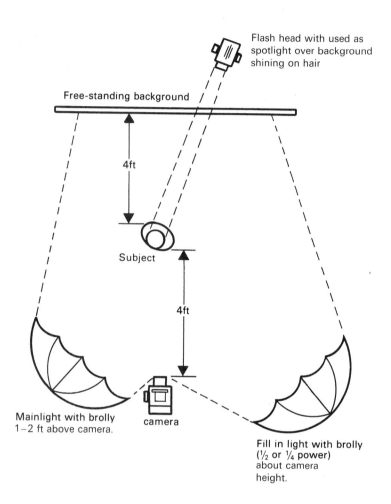

Flash head with used as spotlight over background shining on hair

Free-standing background

4ft

Subject

4ft

Mainlight with brolly 1–2 ft above camera.

camera

Fill in light with brolly (½ or ¼ power) about camera height.

Layout of studio using three mains electronic flash units.

white brolly. The spots have also turned into flash heads but used with a 'snoot' which funnels the flash into a narrow beam. The 'modelling light' has been dispensed with because I use one of my big 'floods' as the main light source and the other on half or quarter power as the fill-in. The spot still lights the hair from behind but I do not like it to spill onto the face because it can distort the features—if the sitter is bald it is not used at all!

A lot is talked in textbooks about 45° lighting being the best for modelling but I use my two flash heads close to the camera, the main one being about 18 inches above

the lens and the fill-in about the height of the lens. All this is for basic head and shoulders portraiture used for politicians, businessmen, engagement sittings, and even occasionally for a formal study of a child. The picture of our daughter Georgina aged about three was taken with just this lighting for a artist who wanted to paint a pastel of her and so obviously a snap in the garden would not do for her to work from. Also the picture of Winston Churchill MP was taken in his study using a cinema screen

This picture of Winston S. Churchill, M.P. was taken in his study at his home. We needed a plain background for some press release pictures so we used his cinema screen! Two studio flash heads, there was no room behind for a third.

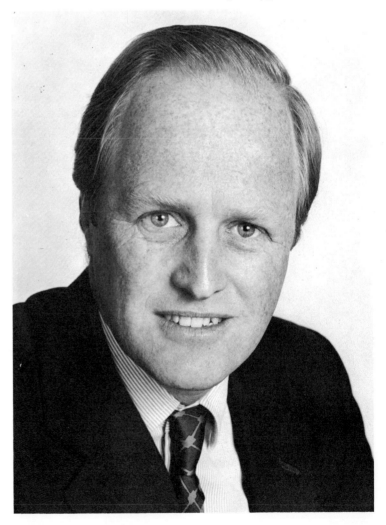

as a background. There was no hair light because there was no room to put it behind the screen!

Although this is my basic set up which suits most faces, it always needs a little adjusting when I have studied (without them knowing) the features of the sitter. In the picture of the late HRH Prince William of Gloucester you will see I have one main light the opposite side to his nose, no fill-in and only gentle hair light. The reason for this was that he had a very wide jaw which was difficult to tone down. His very strong features were his eyes. The lighting hid the far side of the jaw in shadow against the black background while accentuating his startlingly strong eyes. There is no rule about light or dark backgrounds, except that pictures for reproduction on newsprint should be on a light background because the ink shows through the other side of the page if a dark background is used.

The late HRH Prince William of Gloucester. An unusual lighting for a man, but very effective.

An engagement sitting with 'double rim lighting'. For two profiles one uses two studio flash heads from behind the sitters, one lighting the back of the head of one sitter and the rim profile of the other and vice versa.

This is a basic set up which can be used and then moved away from. *Once you know the rules you can break them.*

I realise I am describing a very professional 'set-up', but it is as well to know how we work before adapting your technique to your pocket. The best way to study lighting is to look at as many pictures in magazines and books as you can. Always observe the catch lights in the eyes. They will tell you where the main light was and the fill-in, or if it was taken with one huge source of light such as a big window. The big advertising and fashion studios' use much larger lighting equipment than the portable studio units I have mentioned but we need not study them for portraiture.

A particularly handy piece of portable studio equipment is the mini background. It is simply a normal light stand with a tray and two rollers on it. A 4½ft wide roll of white paper fits into this and extends downwards from this position. You pull it down as far as you want to provide a clean unbroken white ground. When it gets dirty you tear off that section. At the time of writing, it is only easy to get it in white but I asked by wife to buy some

83

dark blue curtain material 4½ft wide by 5ft long. I bought
two broom handles, baby screws with eyes on the end and
some string. I asked her to sew the ends of the material
so that the broom handles slotted into them. I then screwed
in the eyes to each end of one of the broom handles and
tied the string to them so that I could hang it on a picture
hook on the wall or onto the background stand. I use it
more often than the paper!

I have described how I used one flash head with
Nicholas's sitting and I use one on many business portraits
assignments when time is short and all they need is a high
quality mug shot. Before the bigger flashes were intro-
duced I used to 'get by' outside the studio with available
light or using a portable Metz 402. The older models had
an extra head attachment which plugged in to the power
pack so one could use the two heads together if one had an
assistant to hold the second one. I used it mostly in close-
up work on stage when I shot the main show from the
stalls 'live' but needed some quick close-ups of the stars.
You can see in the pictures of Jimmy Edwards that the
main light, which I am holding is placed about a foot above
the camera giving a 'theatrical' nose shadow, while my
assistant has gone round the back and (shielding the light
off the camera lens) shone the extra head on to the back of
the head from one side.

All this seems to be a lot of paraphenalia. But it is easy
to simplify. It is just that working professionally, you
have to be ready for anything. I have often taken all my
gear, which packs easily into a normal car, yet used only
one camera and tripod and two rolls of 120 film for a £50
sitting.

Available light

It so happens there is a big bay window facing southeast
round to southwest in the sitting room of our house. I
had one client with two tomboyish daughters of aged
about nine and eleven. She wanted natural-looking pic-
tures. No studio lights. Out of doors, where it was cold,

Jimmy Edwards taken on stage with a Mecablitz held over the camera and a second head lighting him from the left hand side and from behind.

if possible. I did a few by the river and under the trees, but the light was low and we all started to shiver!

We came indoors and in the bay window (which just happens to have dark red velvet curtains, giving a dark background with no creases!) I put a padded stool (no chair backs please) facing them towards the brighter part of the window, I drew the curtains round to make a background. The only problem was that the shadow side was too dark. On this side I set up my amateur movie cinema screen, and this reflected the daylight into the shadow areas. I did some shots of each of them and then moved them to face the window with the camera in the window. The background? The movie screen again behind their heads. We took some white background shots with beautiful soft front lighting on their faces! Their mother had, in fact, got some studio head shots with no studio! Anyway they liked them and the order showed it!

85

Lighting for older girl indoors from a bay window. See below. Movie screen background.

Flat frontal lighting from bay window using movie screen as background.

The great secret is to use the minimum of lighting equipment. The important part of any portrait is the subject and whether you are going to get a good likeness. How are you going to achieve this likeness? You do not necessarily have to know your sitter already. You must be very observant when you do. Help them to relax. It should not be made like a visit to the dentist but more like being interviewed on the radio. The interviewer's job is to make it easy for you, even if you are nervous, and then get a good sound portrait of you. *Desert Island Discs* was easy. Roy Plumley and I had a good lunch together before and then I selected the discs (Flanagan and Alen, Herb Alpert, Sinatra; none of 'the classics') and then we recorded the interview. This in itself is relaxing because you know if you make a mistake, (and I did,) they can edit it afterwards. Roy said 'You must have done over 1000 weddings, Tom; don't they all seem alike?' I answered 'Yes, I have done over 1000 brides and they are all different which keeps the interest going. A voice from the fish tank (the producer's box) said 'Terribly

86

Side lighting from window.

sorry, Tom, you cannot say you have done 1000 brides.' We changed 'done' to 'photographed'!

Equally with portraiture, a short discussion on the phone before, a chat when they arrive, or you arrive there, and a bit more while you are loading your camera. (I never load my camera before. It is bad luck and they might change their minds about whether they want black-and-white or colour.) Then start on the basic poses.

Posing

Portraiture has to be posed or at least organised however natural-looking the final result is going to be. Look at my wife, Mari's, passport picture (well it was not taken exactly for that but it *is* in her passport and we get some

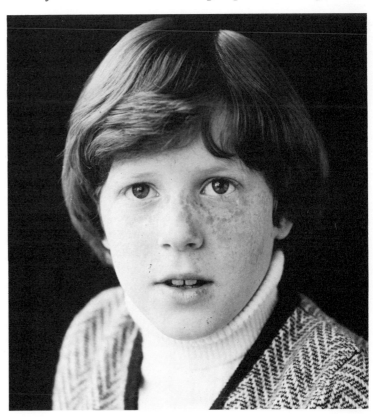

Lighting from side bay window, fill in from movie screen, background consists of velvet curtains.

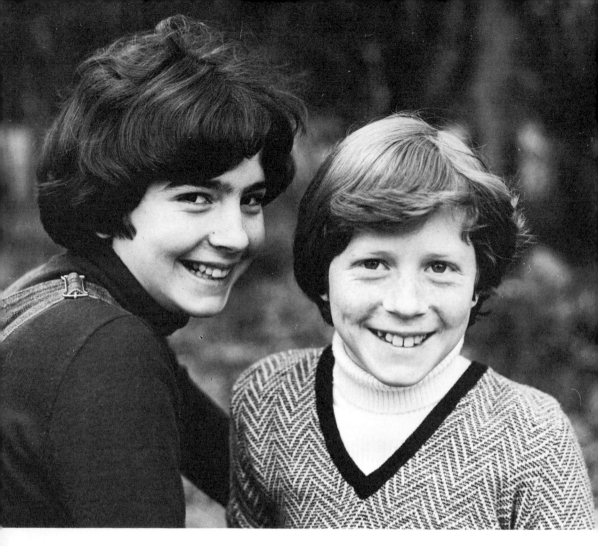

On a bench under a tree in the freezing cold. Top light shows up slight bags under eyes. See p. 84; subsequent pictures taken indoors pp. 86 and 87.

Mari's passport picture! It is a basic glamour portrait pose except that I usually tip the girl's head forward rather than slightly back, as in this one. The hair hides creases in the neck. The centre of the picture is still the inside corner of the eye. Never mind about cutting the hair at the back, the face is more important.

funny looks at customs!). This could be described as a basic glamour portrait pose. The body is turned away from the camera with the arm nearest the camera stretched forward and the hand resting on the knee. The head is turned most of the way round towards the camera and the eyes look into the lens. The rule here is that body, head and eyes should nearly always be at slightly different angles to each other or it will look stiff and unnatural. The head is usually tilted slightly forward. One tycoon said to me 'I know what you mean, me boy, like a dog with its ears pricked eh?' He was right! With men the shoulders are not turned so far away but the head is pointed near the camera and the eyes into the camera. You will notice as we go along I nearly always have the sitter looking into the camera. I think eyes show more than any other part of the face, the expression and character of someone. Also I shoot slightly down on to the sitter

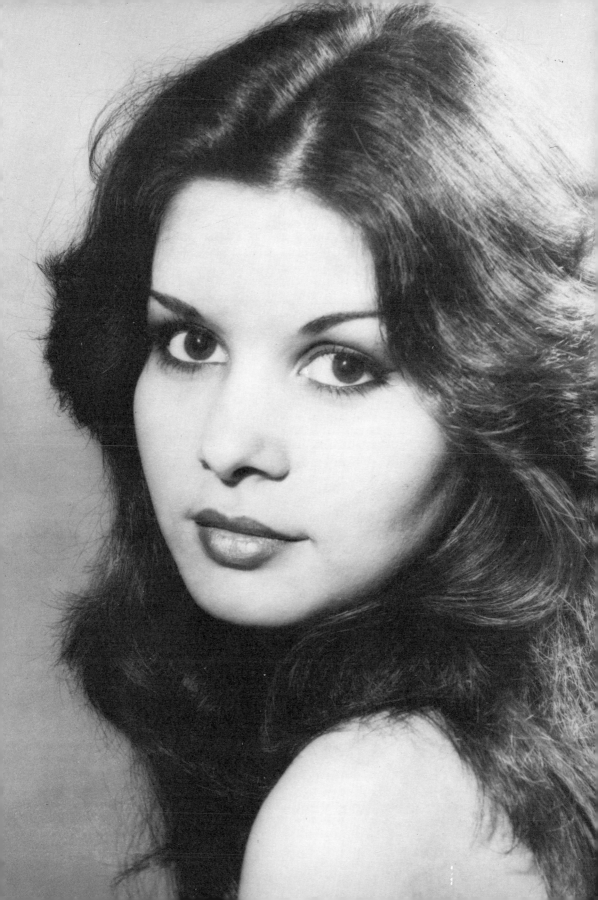

by using a low but not uncomfortable stool and also because I am tall anyway. This opens their eyes and reduces chins.

Looking up at someone makes them look snooty and unfriendly. But you use the opposite technique with fashion three-quarter and full length. Then one has to shoot up a little to make them look taller! Shooting down foreshortens them. Look at any television programme where they are pointing the camera down on the commentator. Come to think of it, television is a very good place to study lighting angles. I suppose it is practical for them to break my rules. On television it would look a bit odd if the newscaster was sitting sideways and then looking round at you. However, on some documentaries (James Cameron is very good at this trick) they look away, showing you something, and then look back to you and comment on it. In close-up a good TV cameraman varies, if possible, the angle at which he is shooting the commentator between shots. The difference with TV and stills is that when a newscaster is telling you the latest he must look at you. (The script is sometimes also on a monitor directly over the lens, so that he can look at you and read his script at the same time.) In movies and drama on the other hand you are usually supposed to get the feeling that you are spying on something real that is happening, so they virtually never look directly into the camera. (There are exceptions films like *Alfie*, with Michael Caine, who was chatting to the audience half the time telling them what was going on.) When you watch TV, don't just follow the story line, analyse how they lit the faces, why they placed people at certain angles and so on. Don't worry, you will forget to do it in a good programme anyway, but it makes a bad movie a lot more fun!!

All this emphasises the need to analyse, not only your subject, but other ideas and techniques. I think it is a good idea for a young new photographer to join a club, but many of the judges of competitions are a very long way behind the times, not to mention the older members, who are often more interested in grain than subject matter!

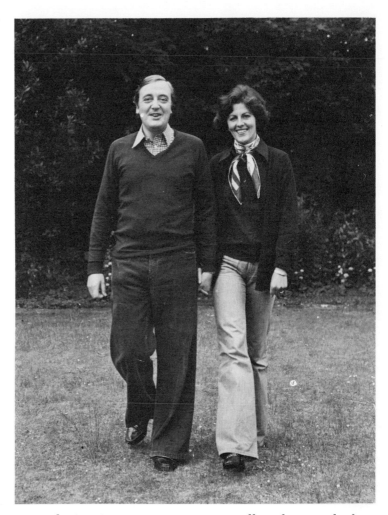

A picture of my brother John and his wife, Liz, taken on their engagement. Walking outdoor shots look natural—lighting can flatter in a studio set-up.

Analysing is a strange art. Normally when we look at someone, we only see their eyes in sharp focus but take in the rest of their character with other senses—their voice with our ears, their smell with our noses, their general appearance and 'presentation' with our eyes, but for a portrait it is their face and expressions that count. With a reflex camera one sees the face in two dimensions on a screen. This helps define the face. Even when I took my brother's engagement pictures I never realised how heavy the bags were under his eyes. (The most difficult people to photograph are your own family!)

When you see that a subject's face is all crooked, what do you do? Many men, have had their noses broken playing in sports. This may mean that the noses point one way and the face the other! The only answer I have found is to point the nose towards the camera, the eyes into

camera, light it as near as possible for flatness and hope for the best. If you pose them away from this angle the nose, being wonky, can look twice as big. These are the sort of problems you get with close-up portraiture.

There was another example of this. A very successful model came to my studio for a job. She was smashing! Only one fault. She had a squint! Do you know that model made a fortune by *never* looking into the camera!

Purpose of the portrait

Many aspects of your approach to portraiture are dependent on what the picture is intended for. With my work businessmen want pictures for press release and publication. But in *your* case what are they needed for? An exhibition? The family? A competition in a magazine? Each subject is different, and must be worked out beforehand, whether by discussion or with your own skill and intuition. For example, to impress the 'judges' in a competition, the subject must be very photogenic. Possibly a craggy faced old man or a beautiful girl beautifully shot in a slightly different way (which will take time). A magazine? They don't know the person and neither do their readers, so it has to be somebody exceptional. The face, in a way, is more important than the photography. How often do you see in exhibitions close-ups of craggy old Chinese fishermen? Why? Because they make beautiful pictures, which catch the judge's or editor's eye. They must be well taken. That needs no more explaining. But for pleasing and selling to the subject's family—that is quite different. Every picture has to be well composed, nicely balanced and reasonably flattering. Who wants a picture of a daughter looking hideous? It is all part of the skill of photography. Let me give you some examples of the problems I have had.

Apart from many 'wonky' noses, and I usually tell them I am having a problem, I met a craggy faced director of a brewery whom I had to take as best as I could. I had an assistant and we took two flash units up the various

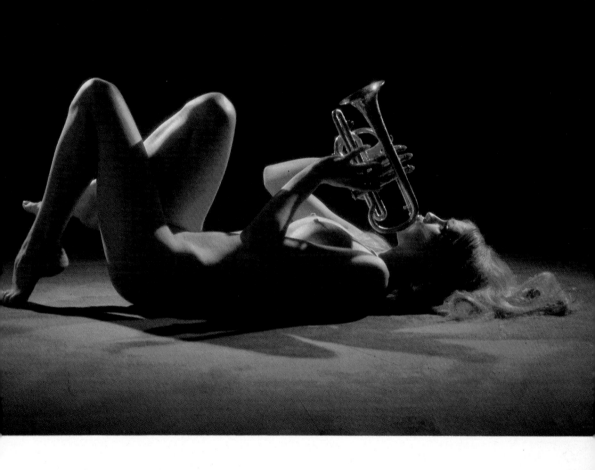

Why photograph a naked girl
with a musical instrument?
Because my agent asked me to,
to promote record and tape
covers all over the world. The
warm texture of the skin was
achieved by using outdoor film
and tungsten lighting.

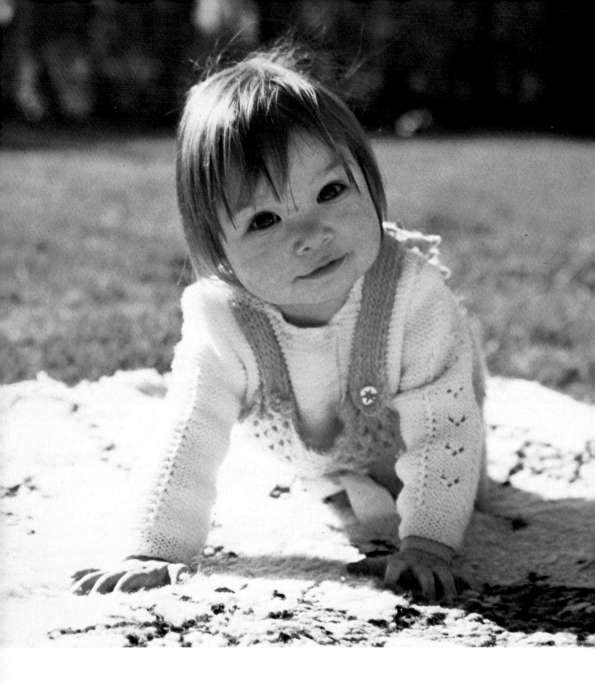

Above One trick I use, is to place baby on a rug on the lawn. The rug gives nice face lighting when shooting into the sun. Note out-of-focus background and sunlight on the lawn.

Opposite One case where flash fill-in was needed and worked. I used a small pocket Sunpak (Vericolor II 1/250 sec at f5.6).

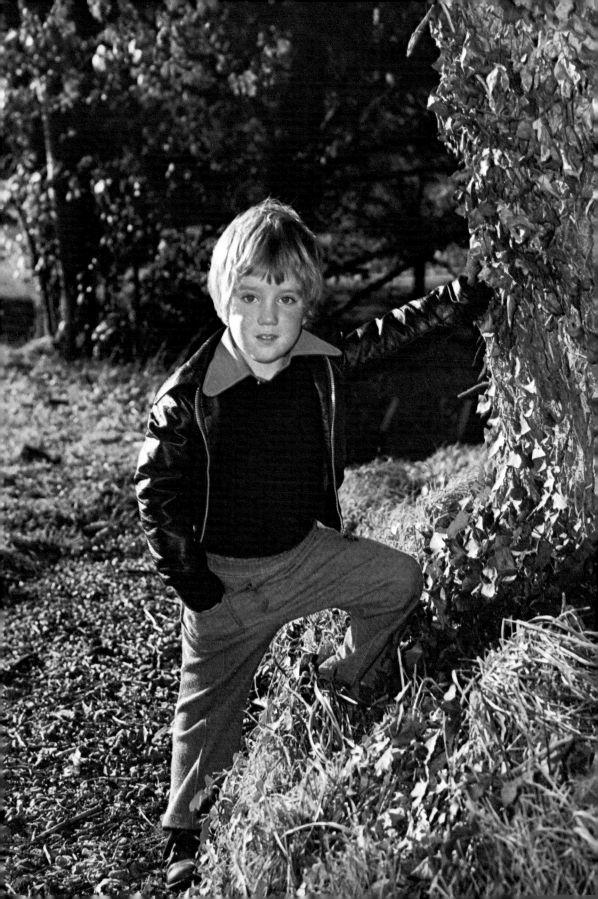

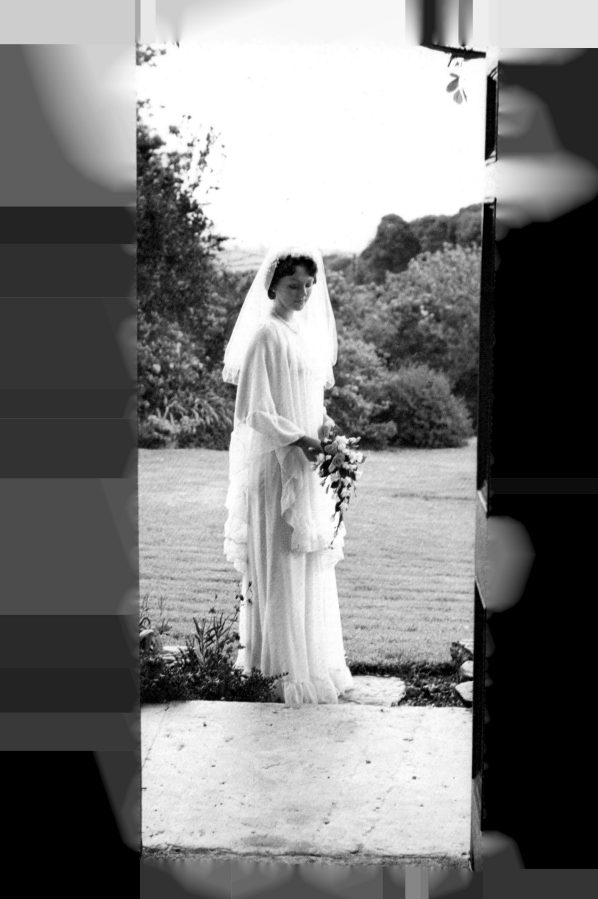

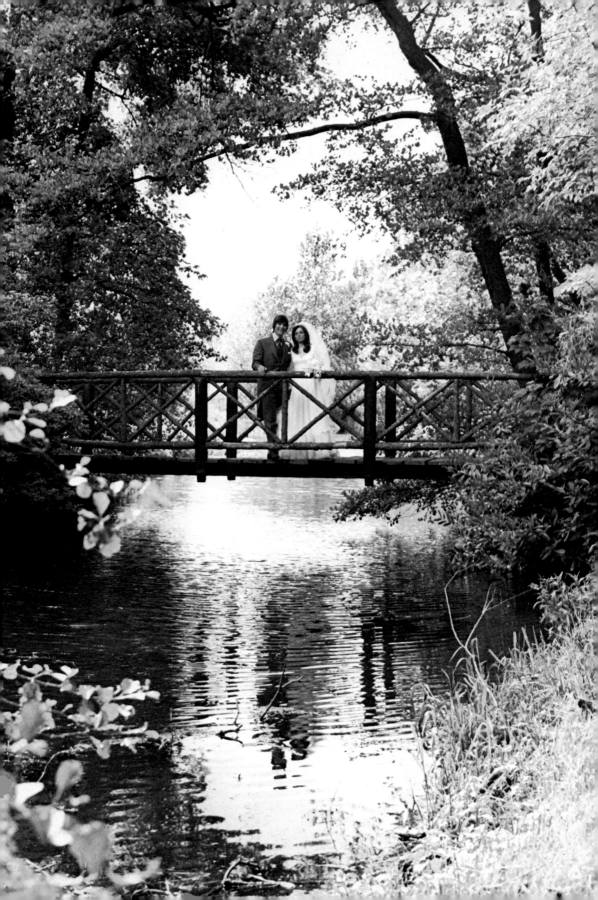

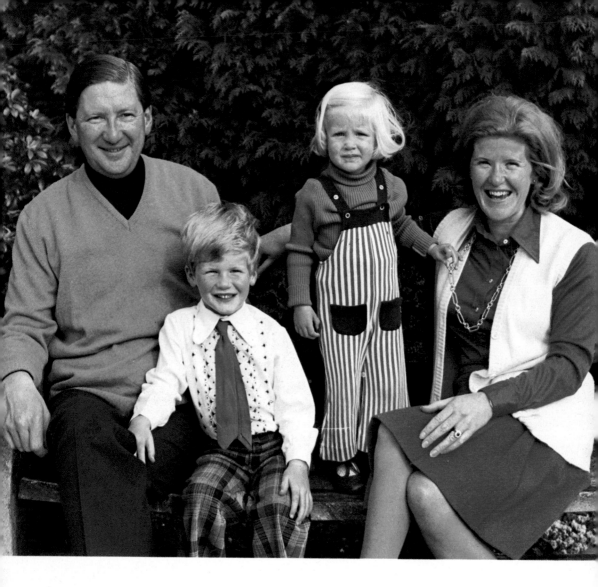

Previous pages Weddings. I always get unusual and artistic shots of the bride alone before leaving for the ceremony.
I looked around the garden and found this lovely spot while bride and groom received their guests. I then asked them to pose for a special picture.

I hold a family group's attention and achieve good 'natural' expressions by asking them to say different words for each shot in quick succession.

Above Teenage Moroccan boy
in Tangier. Close-ups of
interesting types are essential in
any set of travel pictures. If old
people are shy of the camera the
young are only too happy to
pose, for a few small coins.

Following page Eva Reuber-
Staier (Miss World 1969-70)
made up as a clown. Why?
I sold a set of her pictures as her
glamorous self and dressed up
as different characters to a
Sunday newspaper.

lifts with us. When we got to his office it had beautiful soft light from the windows. I shot a roll using this but, having no cinema screen to fill in the shadows, I also did a couple of rolls with the flash. Guess which he chose? The window light pictures!

Viscount Cowdray is a very reserved, but very nice, man. He is now retired from his family business (Pearsons) but is renowned to be one of the richest men in England (according to Nigel Dempster of the *Daily Mail*!). After two failed attempts by PR and press photographers to take a good head shot of him for his company report (when his firm went public) they finally asked me. On the way his secretary said 'Try and get him to smile or look cheerful'. I realised what she meant when I met the great man. He was simply shy of the camera and the other photographers had upset him. His office high in the Vickers building in London had a beautiful spread of windows giving perfect light. Lord Cowdray wears glasses—but this light did not reflect in them. He was very nervous when I came into the office. I did not have to use any electronic flash, because the window light was perfect. The only other problem with Lord Cowdray is that he has only one arm, so the pictures have to be taken from the 'good' side. I realised that I had to 'take command' and started talking to him about polo at Cowdray Park, mutual friends and so on. He relaxed a little, and once he realised I knew what I was doing, he let me carry on. While making preparations I had already worked out how I was going to shoot him. I shot quickly with my Tele Rollei (and close-up lenses) on a tripod and the general chat and occasional words I asked him to say relaxed him and I got my smiles.

I was asked back next year for the picture for the next annual report and went through roughly the same procedure. After the sitting I said, 'I have tried to vary the pictures from last time but I think the best ones will look very like last year's'. He said 'I don't mind, Tom, I just don't want the shareholders to think I only own one tie!'. I fell about laughing and he laughed too and I

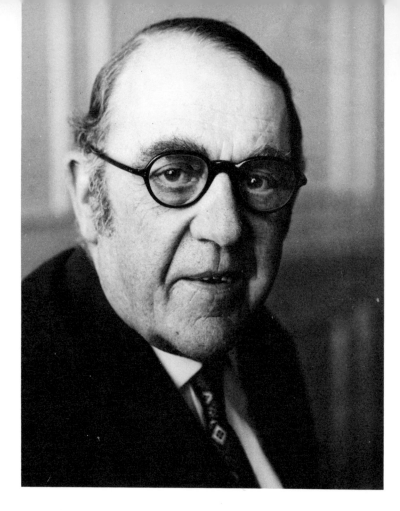

This business portrait of Lord Cowdray was lit by the light from a long window used as a huge flood light. The office is on the 17th floor of an office block facing south and overlooking the River Thames, London.

missed a good expression, but had plenty 'in the can'. They asked me back every year till he retired.

There is a moral to this story somewhere. Get through to your sitter. Be in command. However important they are, you are in charge during the sitting.

If *you* are nervous, don't let it show. It makes *them* nervous. Be quick and efficient, using the minimum of equipment. Never take more pictures than you have to. I never did more than three basic ideas and 36 pictures on Lord Cowdray. Sum up your subject's face, features, expressions and temperament, if possible, without him knowing. Some people want to talk, others don't. Always make them realise that you know what you are doing. If they say afterwards 'Well it was better than going to the dentist!' with a smile you know they have enjoyed it and, if so, you can be sure it was a successful sitting.

There was one banker who played a trick on me. He rang for a sitting telling me that he needed a few pictures, because he was retiring from his job and he wanted to

give one to the cook in the office and possibly a few for the press if they wanted them. There was no rush and I explained that the studio was a bit topsy-turvy because we were moving to the country and the studio was a scruffy bedroom for the time being! He turned up in a taxi wearing a normal business suit and we got on well with a straight-forward set of business portraits. We were a bit slow with the proofs and the order and there was a last minute dash to have them ready. I realised the next morning when I opened my newspaper why the last minute panic. It was announced that he was to be the next Governor of the Bank of England! His name—Gordon Richardson. A very, very nice man. We have met since and still laugh about it.

Another client of mine was a rather overweight tycoon who smuggled chocolate digestive biscuits into his office in his briefcase, because his secretary was trying to make him diet and would not let him have any with his morning coffee!

Sir Richard Costain, the builder, taught me another lesson. I was doing a picture series of leaders of industry for *Sphere* magazine (now no longer published) I had done 24 shots and had enough but wanted to try one more idea. I said 'Sir Richard, could I shoot one more roll if you have the time?' He said 'You are a young man and doing very well. Let me give you one piece of advice. When you are at the top of your profession you must *always* have time.' I have never forgotten that advice and try and use it.

Another tycoon said, 'The man with the cluttered desk, who is always on the phone or has not got 'time' is the less efficient boss.' Most of the bosses I photograph give the impression they have all the time in the world for anything that might crop up. Their genius is delegation of duty, but they know what is going on.

Photography of businessmen is a branch of my business that I really like. I think, in some ways, the big tycoons are the most important people in the country. It was lucky I had worked in the stock exchange before starting to shoot them. I knew something about the companies

and it gave me a point of communication.

In 1978 I photographed most of the directors of Arthur Guinness and Co. Since I have drunk their beverage for many years at pubs all over the country, I had plenty to talk about and told each of them, that, no matter how many directors they had and gave me to photograph at my normal fees, it would never pay me back for all the Guinness I had drunk in my lifetime! They all liked that introductory story.

Portraiture of girls is slightly different! More time should be spent discussing clothes, make-up and hair on the telephone beforehand and before starting to shoot. They obviously want to look their best in the pictures.

Nowadays we don't have retouching to help so we have

This picture of Peter Guinness was done with two studio flash heads as main and fill-in lights with a plain office wall as a background.

How *not* to take a picture of a pretty girl. To demonstrate the *wrong* sort of bounced flash I took Mari in a panelled room with a high white ceiling with a small flash bounced off the ceiling. Result—dark eye sockets. Very unflattering!

to do all we can to make the subject look nice beforehand and light the picture properly. More of all this in the glamour chapter.

Whatever light you are using, do be in control of it. A portable flash unit might serve for weddings and the occasional portrait on stage etc., but beware of trying to

bounce the flash off a too high ceiling, or of using it with yourself too close to the subject. It is fine in a small light-painted room where you can use $f5.6$, point the flash head (on full power) into the corner of the room and shoot away. But beware of a panelled or dark-painted room even if it has a light ceiling. The eyes come out as dark sockets, and no pretty girl wants to look as if she has two black eyes!

One well-known lecturer/photographer suggests that people should always be taken in their own surroundings. He does admittedly concentrate on artists, writers, etc. He also suggests mixing the available light with a tungsten floodlight. In a way I can see he has more control (in black and white) and, of course, his results are superb photographs. But I often wonder who buys them—since those people are notoriously impecunious! It is all very well to give this advice but most people don't have interesting backgrounds. For me the interesting part of a person is their face, so that is why so many of my pictures are close-ups. Nor do I have a London studio with £6000 a year rent and rates and £6000 a year outgoings in basic staff and overheads. I can take my studio to the subject in the back of my car.

11

Outdoor Portraiture

I remember watching a TV programme in about 1956, in which Tony Armstrong-Jones and Dorothy Wilding were being interviewed together about photographic styles. At one point Tony said 'I don't like studio work–I much prefer shooting with natural light.' 'Mr Jones', replied Miss Wilding rather tartly, 'In *my* studio I can put the sun where I want it.' She had a point. But so did he, except that there is no such thing as 'natural' light. Why? Think about it . . . it is all *directional* light. Is window light natural or is it being directed by the window? If you sit somebody in the middle of a lawn on an overcast day, is it natural? No, the light is from above only. Do you get the point?

Anyway, as it happened, I joined Miss Wilding and learnt her techniques. Not surprisingly, for years I went along with her basic principles when I had taken over her business—and I have always been very conscious of lighting, even when shooting out of doors.

One day on one of my courses on photographing people, I was searching for a simpler way of explaining lighting for portraiture and glamour out of doors, it came to me! 'Why not think of the great outdoors as one gigantic studio.' I was immediately fired with enthusiasm, though the new approach shook my students!

I explained to them, 'In an indoor studio you would use a main light, whether soft, as when using brolly flash, or hard, as with a spotlight or flash without reflector. And sometimes you might add a spot or extra flash from behind the head to light the hair. You might also use a fill-in light'. Then I took them outside onto my old fashioned, but extremely practical, verandah, which runs along the house facing south. It was a bright day with hazy sunlight. Placing one of the students a little way from the others I showed them that her face was strongly lit from the south but with only a little fill-in from the brick walls. That light was unflattering, so I placed the small movie screen quite close to her between her and the brick wall. This reflected light into the shadows: better but not very glamorous. Next I took the course members

into the garden and placed the model facing them, so that she was facing south but still under the verandah. Her face was frontally lit by a beautiful soft directional light. Since there was a balcony above her, no top light came down to accentuate eyebrows or eye sockets—or even wrinkles, which are exaggerated by side top lighting. The students began to understand how I manipulated the available light to achieve the effect I wanted.

Now you won't find verandahs dotted all over the countryside; so I repeated the same exercise featuring a craggy faced chap from the group and placed him under an overhanging tree. The soft south light was the equivalent of one huge flood light or a couple of big brolly flashes close together. Our experiments showed that studio lighting techniques could be applied to what is found outdoors, making a huge studio.

A little later the sun came out, so we did some further practical work. I demonstrated how people squint if looking directly into the sun and how direct sun produces very hard shadows. The sun is an exceptionally strong spotlight, so why not use it as a back light? It provides a delightful halo effect on the hair. What shall we use to light the face which should be softly lit? Again, I used the small movie screen reflecting the sunlight back onto the face and giving a light like a big flood. I reminded them that exposure readings should be very close to the subject's face without the sun spilling into the meter. I warned them to beware of automatic cameras with no manual override and with no provision for locking an exposure taken close-up.

In our direct sunlight work, I placed the model against the shadow side of a high hedge, giving a dark, out of focus foliage background. The sun highlighted her hair and body. The screen was placed a few feet in front of her face fairly close to the camera. Later in the day, when the sun moved round to the west, we did the same kind of thing using the white wall of the boathouse as the main light on the face. I reminded them always to use lens hoods.

Wherever you go the sun or daylight offers you a marvellous range of lighting conditions.

Mostly, it is best to avoid the midday hours in summer (but not in winter). The high sun throws hard shadows which are difficult to control. But for a character study of a peasant in a hot country, direct sunlight can be the main light on the face because they are used to it and the bright surroundings will usually give enough fill-in for the shadows.

If the sun is a spotlight, then the open sky is a soft flood, which you can manipulate by the way you place your subject. 'Natural' reflectors such as light-coloured walls, burnt grass, or sand and movable reflectors such as white towels also stand in beautifully for floods. Whenever possible I avoid using fill-in flash.

Although I carry a baby sunpack flash with an extension lead, I try not to have to use it except on weddings. A flash is the equivalent of a small strong spotlight and, since the sun is already a spotlight, this means that there will be two distinct shadows—which gives a very unnatural looking effect. The answer is to be sure that the flash is giving you less power than the available light (about half power is right). Avoid at all costs *over*-exposing the flash outdoors.

One of the most common faults with beginners in the studio or out-doors is getting two main lights of equal power and therefore two sets of obvious shadows. This is messy and looks completely unnatural. There should always be *one* main light source, with the others as either fill-in or rim lights.

The great outdoors provides an infinite array of backgrounds. Too many photographers think only of the subject, with the result that strange things seem to be growing out of heads and bodies, and the whole composition is lost. The answer is to choose the plainest background you can.

It is the amateur's birthright to be adventurous. Whereas a local photographer may have to play safe and shoot 6 pictures against the same back-ground every

My Christmas card picture of our daughter, Georgina. 1/500 sec and *f*22 shot against the light.

time, an amateur has all the time in the world to try different lighting techniques, silhouettes, mood pictures and so on.

I wanted something a bit different for our 1977 Christmas card. I took our daughter Georgina to the edge of the river at the bottom of our garden on a sunny November day when the sun was low and shot her directly against the water of the river where the sun was reflected. I wanted a silhouette, so I used 1/500 sec at *f*22 but it was still overexposed and flared and needed a very long exposure in the darkroom to get the effect!

I have not mentioned much about cameras, but what I have written applies to any camera with controls and capable of fitting a lens hood! My personal preference for portraiture is the Tele Rollei with close-up lenses for

head and shoulders and the standard lens for three-quarter or full length shots of children. I use my tried-and trusted Tri-X or Vericolor II and may increasingly use Kodacolor 400. If I need slides, out comes the Canon F1. I am often asked the ideal focal length of lens for portraiture. The 135 mm of the Tele Rollei is hard to beat and for 35 mm I would say 80 mm to 100 mm. If focal length is too short you get too much background detail in the picture and distortion from having to get too close to the subject for a head shot. Anything too long and you are so far away from your model that you lose contact with her!

One tip while experimenting with outdoor lighting and the control of it, is to place yourself where you are going to put the model and see the part of the sky which is lighting you. It will also tell you if it is comfortable on her eyes. For posing, show the model by doing the pose yourself, however ridiculous you may look, especially demonstrating glamour poses! It really helps her.

I suppose I have actually been using the great outdoors as a studio for years without actually realising it! Though I am newly aware of it, it is not exactly a new concept.

12

Personality Portraiture

Karsh once said he could estimate the success of shooting someone famous by how many sleepless hours he had had the night before! The more famous the person, the more nerves, especially if you have never met them. One way to overcome them is to read up on him or her in books, magazines and newspapers. Try and see them if they appear on television and study their good and bad points. One comforting thought is that, most people are very nervous of *being* photographed, especially if it is for important use. I had one sitter, a successful tycoon, who spent the morning at his hairdresser, then took his PR man out to lunch. He seemed very relaxed and was certainly very co-operative, other subjects show their nerves with gruffness; most pretend they hate being photographed. 'I am only here because my secretary told me to turn up', says many a businessman. Most are so vain they keep reordering pictures taken years before because they make them look younger!

The first tycoon I took was the late Lord Rootes, a fearsome subject for a young photographer, but as soon as I mentioned I knew his granddaughter, life was much easier for both of us. One titled country gentleman was really only happy when being photographed outdoors with his dogs!

In 1966 I photographed Princess Grace of Monaco and her children. I did all the pictures out of doors to make them as natural-looking as possible. These shots were for an exhibition of my pictures in Monaco for British Week. I also ran a Discotheque Londonienne for three days there to support the cause. The sitting went quite well and relatively easily although I was very nervous. The pictures were liked by the family and Her Serene Highness passed a massive 40 shots for the exhibition and press use. Later, during the week, it was part of the Rainier's duty to visit my disco. Being the host, it was my job to talk to them! I brought up the subject of the pictures and thanked her for being so cooperative, passing so many and making the session so easy for me. 'Not at all' she said, '*You* made it easy for us. It is far more difficult for us to be photo-

One of my favourite shots of HRH Princess Grace of Monaco (and one of hers too!) taken in 1966. I lit the profile by asking her to stand between the palace wall and some dark trees, so that the light came from in front, above and behind her.

104

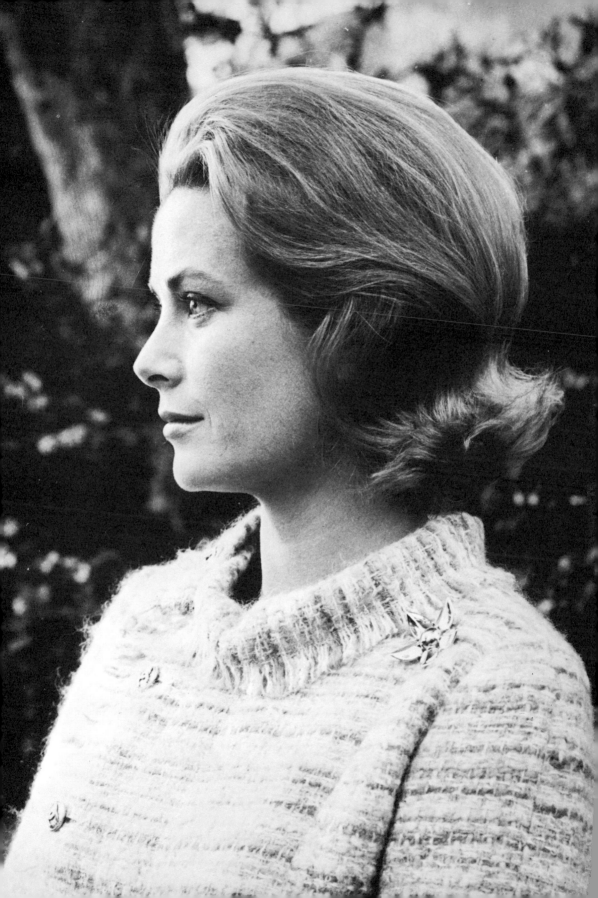

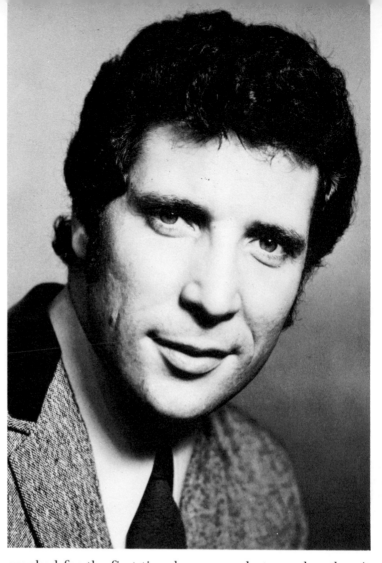

Tom Jones was almost as nervous as I was when he visited my studio.

graphed for the first time by a new photographer than it is for you who are used to photographing the famous.' I was amazed. With all her years in Hollywood and as Princess I would have thought she would be bored stiff with being photographed! At a later date I photographed Prince Rainier in his office in the 'Pink Palace', in Monaco.

The more important the sitting, the more important the preparation. I always have a spare—of everything! Two Tele Rolleis, two sets of flash, four flash leads, (they seem to give up working at the worst moments for no particular reason) one tripod is usually enough, two standard Rolleis and a wide-angle one just in case. I discuss with the secretaries or the subject the exact purpose of the final pictures. Mind you I do this for most sittings anyway, but when dealing with the famous it is best to double check.

Although I have had many hundreds of pictures published I have never actually worked for a magazine or newspaper. I have always been a 'private commission' type photographer. I have had one or two disasters. When building my name in the late fifties, it was the custom to invite the famous for a photographic sitting free of charge. This way I had pictures to offer the press and put up on my studio walls. I was still very green. My two big disasters were Hughie Green and Frankie Vaughn. The pictures never saw the light of day and I guess the stars were quite happy about that. I just could not reproduce the glamour of the stage personality in the studio. However I had more luck with Jon Pertwee, Jill Bennett, Heather Sears, George Sanders, and others.

The free sitting was a recognised way of keeping the studio busy. One invited top debs, engaged couples, authors (Evelyn Anthony still comes back to me) as well as show biz people.

13

The Theatre and Showbusiness

It takes a bit of cheek to invite the famous to one's studio, but many of them need good pictures anyway and if they turn out well they are pleased and will come back when they need new ones. I did some good pictures of Derek Nimmo for the musical *Charlie Girl,* and his press agent brought Terry Scott and Nicholas Parsons along to the studio for paid sittings.

My favourite lady of the theatre must be Dame Anna Neagle. If there is such a thing as a beautiful personality, she has it. All through *Charlie Girl* I never heard her say a nasty or bitchy thing about anyone, and I really think she never *thought* a nasty thought. Of the men of the stage my most regular client has been Danny La Rue.

How to get into theatre photography?

One can start with amateur productions. The problem is that the lighting is so appalling and the sets usually so tatty they do not make good examples of one's work. What one guy I met recently has done, was to set up a flash off stage and, during breaks in the dress rehearsals, he would ask the actors to sit for him. The results were very good.

I did it another way. I met a theatrical PR called Torrington Douglas (TD to his friends). He had the job of organising the publicity for the London Stage version of *Flower Drum Song.* This was long before the movie but it had been a hit on Broadway. I asked him to persuade the producer, Jerry White, to let me shoot without flash during the dress rehearsals and if the results were good enough for the front-of-house pictures, it would save a long and expensive (in time and money) staged photocall which was the practice at the time. Jerry agreed and one night I shot the first act and brought the best of the results to show him the following night, 10 × 8 inch glossies. He was amazed that one could get such good quality pictures in straight theatre lighting. I did shoot a lot of negatives and my staff worked overnight to produce the pictures.

My method was, and is, to use a Tele Rollei on a tripod

Dame Anna Neagle in *Maggie.* This picture was taken at a press photo-call.

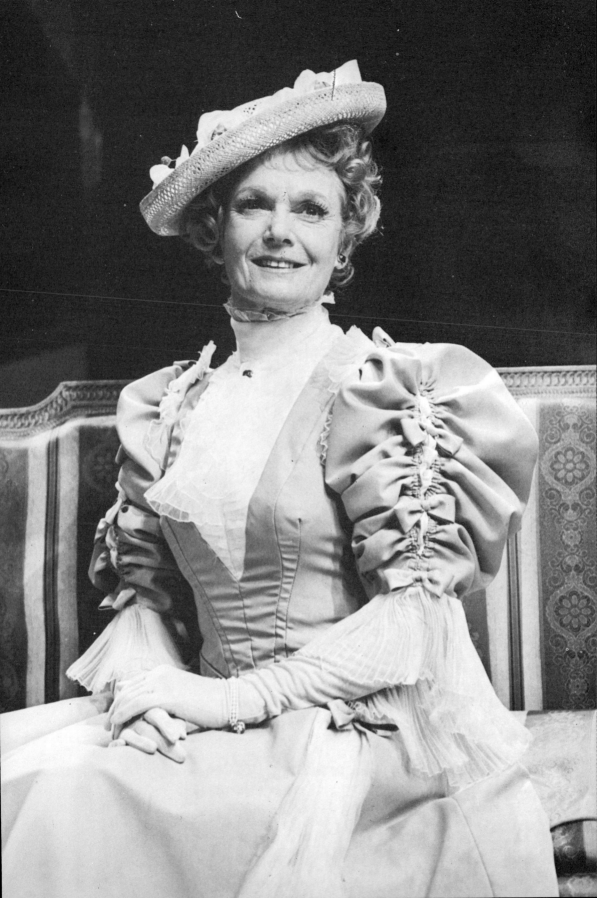

in the stalls, with the head of the tripod left free to pan right and left. The characters were 15 to 20 feet away, so the length of lens was just right for full length. I soon discovered the difficulties. The main characters were in spotlights (limes) from way up behind in the 'gods' the exposure for them was about $1/125$ sec at $f4$. The general lighting on the other characters was about $1/30$ sec at $f4$ and there was no light on the scenery! The reason is that the eye takes in a far wider range of light than a film. It was no good overdeveloping too much (which I did those first few times) because it 'burnt out' the main characters! The other problem is that most of the time the characters are talking to each other from 5 or 6 feet apart (except for the clinches!) No one can use a picture of two people with a great mass of black between them. One has to wait until there is a 'tight' group. These pictures had to be clear enough to serve as press handout pictures as well, in spite of the many dark backgrounds.

Jerry asked me to photograph his next musical London stage production, *The Sound of Music*. This was before the movie was made but the stage version had already been a success on Broadway. There was no great confidence in it before it started. Who would want to see a show with nuns and soppy kids? The answer—everyone! The music was superb and the actors, a great team. In this case Jerry asked me to shoot studio shots of the main actors and actresses in advance for the programme. This meant extra work and sitting fees and gave me a chance to get on friendly terms with the main leads. There were no really big names but Constance Shacklock as Mother Superior and Olive Gilbert as another nun were dears. (Olive's love of her life was Ivor Novello and his musical plays. She had appeared in many of them.) Constance was an opera singer, or certainly sounded like one. No need of microphones, for her! Harold Kasket had a reasonable part and Eunice Gayson who was trained in the Rank Organisation starlet school stayed through the whole run. I cannot remember who played Maria (the Julie Andrews part in the film) but they were all lovely which is not

always the case, especially with the older Hollywood stars, who are trying to do a comeback on the London stage.

The Sound of Music ran for years and somehow I got an introduction, through TD again I think, to Harold Fielding, the producer. His wife, Maisie, and he are a real couple of theatrical characters. Harold is full of bounce and energy and Maisie organises all the costumes for his shows. They are enormous fun to work with and we

The *Charlie Girl* picture book.

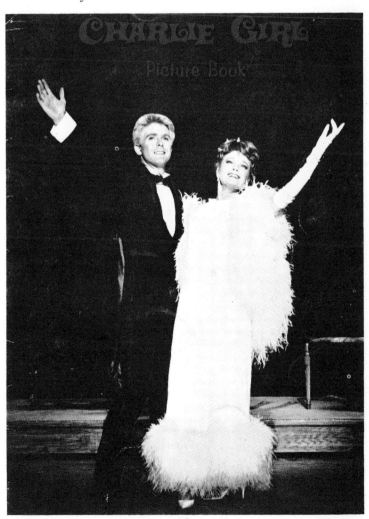

invented between us something called a theatrical *Picture Book,* of the shows. Harold is a bit of a rebel, like me, and always prepared to try anything new. He started life as a boy genius violinist. Our first big show was *Charlie Girl,* with Anna Neagle, Derek Nimmo and Joe Brown. It was always designed as a family show. Although the critics hated it (apart from *The Sunday Express)* Harold was not to be outdone. He made a commercial and spent a fortune on television advertisements. It worked and the public loved it. The *Picture Book* was organised this way. I took my usual action shots and did three sets of selected 10×8 inches (working overnight again). We met the printers the next morning in Harold's office, which, luckily, was round the corner from my studio and flat. We spread the pictures all over the floor there and then we did a 'layout'. There were virtually no captions—just a list of credits at the back. (The programme gave everyone full credit). By the first night everybody was given a free *Picture Book* and programme and there were full huge 'blow-ups' outside the theatre as well. It was really hectic but I enjoyed working with the theatre.

I did other shows with Harold such as *The Great Waltz.* We did a full job on a show with Stanley Baxter called *Phil The Fluter.* It was hit by everything. Flu in the cast, a lousy winter, epidemics of flu in the country, resulting in low audiences and losses. The theatre management exercised a clause in the contract that said that if the audiences dropped below a certain level the show had to close. It did. The next one to go in was Danny La Rue's first London stage show, produced by Bernard Delfont. I was asked to do the pictures. How could I refuse?

For pre-production pictures of Danny as a 'bird' had had to come to my studio with six wigs, five 'frocks' a dresser and all the trimmings. I had never had a man dressed as a woman in my studio before, neither had he ever had to be photographed in drag outside a theatre or his nightclub. He also had a streaming cold and the first thing I had to provide were asprins! Not a good start! My staff were fascinated. I used the big, 9 foot wide

paper backdrop, as for a model or fashion session and really expected him to 'perform' for me. He will not mind me saying that he was like a new model who does not know where to put hands or feet! I had been to his club a couple of times and knew his type of act (his partner in those days was Ronnie Corbett and I have never laughed so much!). I had to direct him as if he were a new model. 'Push the knee forward', 'Hands down by your hips', 'Keep the elbows close to the body', 'Raise the front foot's heel', 'Smile into camera', 'Smile at the (imaginery) dress circle', and so on. The pictures were adequate and

Taken at the 'posed' photo-call of *The Wolf* with Edward Woodward, Leo McKern and Judi Dench, using double flash lighting.

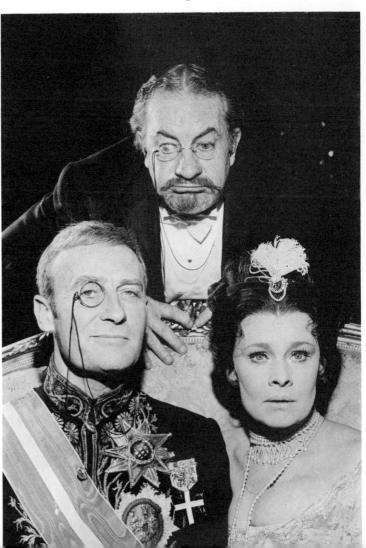

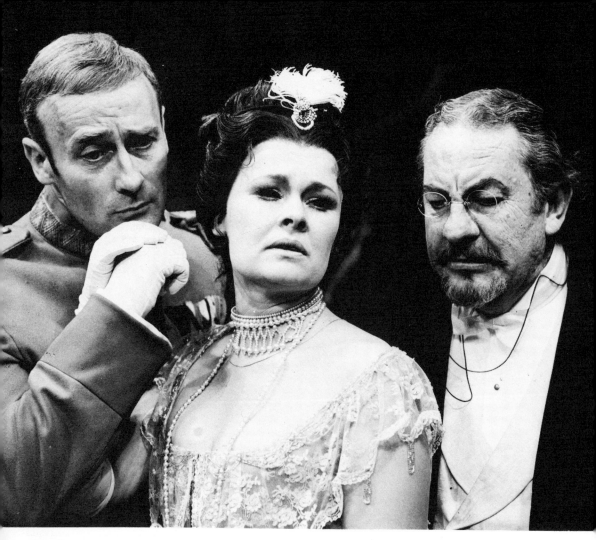

Posed photo-call for *The Wolf*. Left to right, Edward Woodward, Judi Dench and Leo McKern, organised theatre lighting.

had to be done because the theatre was not available and pictures were needed for advance publicity.

For all his big shows since, we have done the pictures in the theatre and we work together so well that I can almost say 'Position A, expression B!' He has been back to the studio for shots of himself as a man, and I really think these were the best pictures of all. They were widely published.

The posed photocall

Although I have not done many of these there are times when you just cannot get enough good pictures from the stalls or you want a few heads and small groups in close-up. The other time it is easily possible is when a play is running in the provinces before coming into London. The best example I have of this is a play called *The Wolf* with

Edward Woodward, Leo McKern and Judi Dench. It was running in the Oxford Playhouse, before moving into London. The producer suggested I come over and see the play, making a few notes. A couple of afternoons later we did a posed photocall on stage. I organised the lighting for some of the pictures to be all the white front light on full power cutting the wing lighting down to minimum. This gives a natural-looking stage-type lighting. Other shots I did with the twin-headed Mecablitz, to get really sharp blow-ups for front of house. I get them to recreate a few

This 'typical' expression of Harry Secombe was taken at a posed photo-call of about 10 minutes duration after shooting live. I needed some 'close-ups' of Harry. Lighting was 'full-on' theatre lighting with no flash.

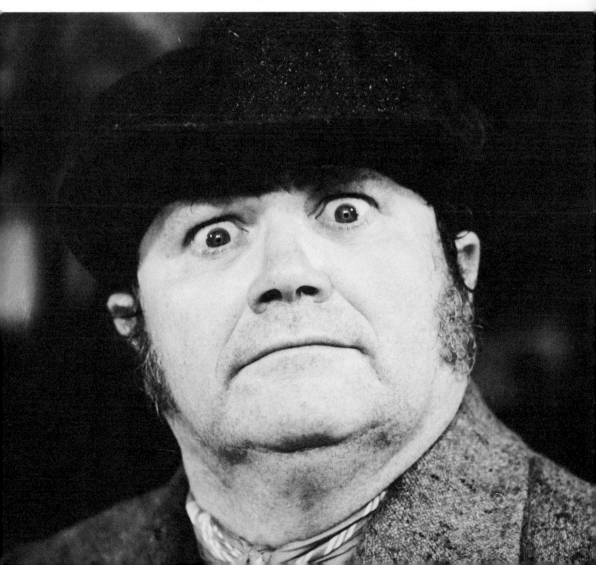

of the scenes, even running through a few of the lines and I often regrouped the actors closer together for the camera. Most of the time I was on the stage. The director was there to offer advice and make suggestions. It was a very successful session taken at an easy pace, the pictures were good quality and the show ran well in London.

Only too often a show is so far behind in rehearsal that there is no time for this sort of photocall, but it is essential for big production numbers in colour, or where the lighting is impossible. I was asked by Paul Raymond to do the pictures for his big Folies-type production. In one scene there was a totally nude ballet, men and women,

Nude ballet in Paul Raymond's *Royalty Follies.* This was the 'posed' call where I did not know where to put my exposure meter!

in virtual darkness as far as the camera was concerned. He insisted that I have a second try for that with extra lighting set up. The boys and girls wandered around the stage with nothing on completely unabashed (it was *me* that was embarrassed) I had to go up on stage to take a light reading but did not know where to put my exposure meter! The best part of the show were the dolphins!

I have done many stage productions but now work only for producers like Bernard Delfont and Harold Fielding. I have had two nasty experiences where a particular producer has got me to do the pictures of shows which have failed and come off quickly. He scarpered and I was never even paid expenses. If this type of photography interests you get hold of a copy of a book called *Contacts* published by *Spotlight,* the actor's directory. It lists producers and theatrical agents and PR's. Every show has a press photocall whether it is part of a run-through or a specially posed one. Read the papers to see what is arriving, ring the theatre manager to find out the PR's name and ask if you can attend the photocall. Usually he will ask where you are from and you can say 'freelance' or get your local paper to give you a letter to say they are looking for pictures of local girls in the show. The PR is usually perfectly happy to have a big crowd of photographers at his 'calls'. It is a mark of success for him and it might work for you.

14

Royal Photography

Royal photography, except for candids at walk-abouts, is not something the average amateur is likely to experience, but you might be surprised how many virtually unknown photographers have been asked to take pictures of the Royal family. When they go on overseas tours they are given presents and the traditional present they give in return is a signed framed portrait of themselves. This goes for all members of the royal family, who carry out public duties. Someone has to take them and it is sometimes me but there are plenty of others! Peter Grugeon did marvellous pictures of the Queen and Prince Philip used during the Silver Jubilee.

A few years ago Norman Parkinson did some superb pictures of Princess Anne even flying in a make-up man from Paris. Ever since, other members of the Royal Family keep asking him. I cannot think why they did not realise what a great photographer he was before. He is the grand master as far as I am concerned.

The other use for royal pictures is for press release such as Tony Armstrong-Jones's pictures of HRH Princess Anne and family for her 28th birthday.

The 'press release' pictures can usually be informal as were my engagement pictures of Prince Richard (now the Duke) of Gloucester and Birgitte. Others, such as the last pictures I took of HRH Princess Alice Duchess of Gloucester, are for formal occasions, ball programmes, framed pictures in the messes of regiments of which she is colonel-in-chief. The press are not usually interested in formal pictures.

With a few exceptions, no one makes a fortune out of royal pictures. The ones that are issued to the press are all organised by the agency Camera Press. They can only sell to the papers at the lowest space rate and the photographer gets half of this from the agency. Only sheer quantity, sold all over the world, will make any money. For private pictures, we do not charge sitting fees and keep our prices as low as we can.

I have done about 25 commissioned royal sittings, the first being Prince Charles and Princess Anne for National

HRH Princess Alice, Countess of Athlone with (left) Kate Abel Smith and (right) Alice Liddell Grainger, her great grand daughters.

Saving Stamps when they were ten and eight respectively. In those days (1959) we took the whole studio to Buckingham Palace the night before, did test exposures and came back at the appointed time the next day. Charles and Anne were brought in. I was using the huge plate camera. I photographed Charles first, and when I had finished he came round the back of the camera and looked at Anne upside down on the focusing screen. Anne winked. I said 'Look Charles, Anne's winking at you'. A small voice from the front said 'I am not winking at him, I am winking at you!' It was the first and last time!

As I write, the latest royal commission I have been asked to do was a private sitting for HRH Princess Alice, Countess of Athlone who lives in an appartment in Kensington Palace and is 96. She wanted a private set of pictures of herself with her great grandchildren. No press release. I visited the palace and with her secretary

worked out where to take them. Because of the age gap it was not an easy commission. Eventually I chose a small light painted front hall and decided to use the minimum of equipment and shoot as fast as possible, in case she tired quickly. I used one flash head with brolly!

One is only asked to take these pictures through recommendation or reputation or both. When you think that the Royals can ask any photographer in the country and they would come flying, it does make you feel proud they have asked you. You certainly have more nerves before a Royal sitting than anything else!

For events such as charity galas we do not get asked. There is a Royal rota organised by Buckingham Palace

A formal picture of the Duke and Duchess of Kent for official use.

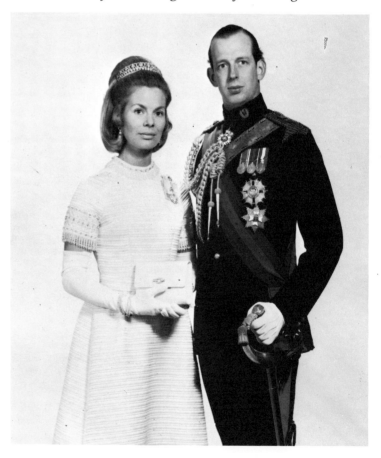

Press Office and for each big event only one newspaper and one press agency is allowed in. The others have to battle on the pavement. The Queen Mother is popular with everybody. She knows just how to stop 15 feet from the press boys, pause and give them a beautiful smile. The rota for inside pictures means that each newspaper and agency takes it in turn and then make their pictures available to everybody else. It is a system which works very well.

There is not so much private royal photography around as there used to be partly because some of the royals themselves are good photographers. The Duke of Gloucester has had books published. The Duke of Kent has his own darkroom, and one often sees the Queen and others with cameras in their hands.

The British press are, on the whole, very polite about our Royals, and quite right too, because they work much harder than most people realise.

15

The Wedding Scene

There is a lot of contradictory nonsense written and talked about wedding photography so I shall try and sort it out! One book on the subject written by an American lady suggested taking photofloods to a wedding and one of the pictures she used was obviously taken at a Jewish barmitzvah! During the wedding seminars I have organised or attended there is one thing which is very clear. No two photographers think or shoot alike! I am going to divide this chapter up into three sections—how the local church photographer works; what an amateur can do to supplement this; and how I cover a wedding.

Local photographer

He usually starts by working for someone else and then branching out on his own. Since weddings occur mostly on Saturdays he combines them with industrial and commercial and/or portrait photography during the week usually working from a local shop with a small studio behind. He usually only takes pictures at the church with a quick dash back to the reception to do a 'mock-up' cake cutting picture if he has time before dashing on to his second wedding of the day. He gets his work by his reputation, recommendation, shop front display, reading the engagement columns of the local papers and approaching the bride with price lists and samples. He gets requests for details through the classified telephone directory. He might get to know the local car hire firms, jewellers, wedding dress suppliers, caterers, banqueting halls, the vergers at the churches—all of whom can inform when there will be a wedding or who is getting married.

Because he cannot charge a fortune he has to keep his shooting to a minimum with maximum coverage, ie. no wastage. He will try and cover each wedding on 36 exposures. I think the basic coverage should be as follows:
1 The bride arriving with father.
2 Asking the father to step to one side and shoot one or two of her posed nicely on her own, unless she has a heavy veil and you cannot see who is under it!

'Bride before' pictures must be taken in any full coverage of a wedding. Here I did my favourite semi-silhouette picture taken against the light with the soft sunshine on the window behind and no fill in.

122

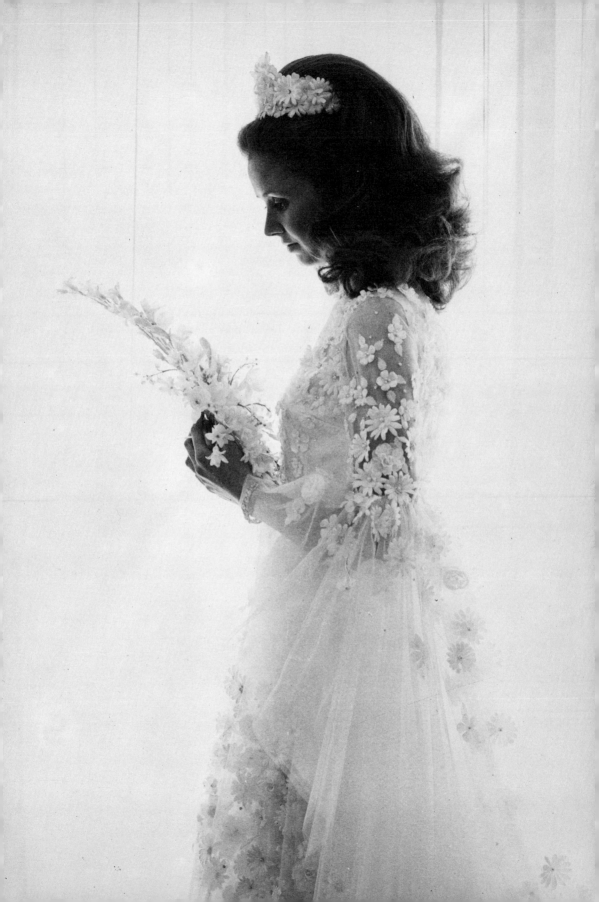

3 A shot from the back of the church giving the general scene from behind without flash but with tripod if neccessary. The vicar may need a bit of convincing about this one. Shoot it during the first hymn, specially if you have a noisy shutter.

4 Signing the register.

5 A flash shot or two coming down the aisle.

6 Couple at the church door full-length and three-quarter length. Several shots, preferably smiling.

7 Then bring out the best man, who stands next to the bride and the bridesmaids whom the photographer organises into a pretty group. Several shot again asking

It was just one of those days. The bride was walking to the church on father's arm, when the heavens opened and down came the rain. What was there to do but lift skirts and run. My camera and I got wet but we also got the pictures and a movie man got it in full colour and action.

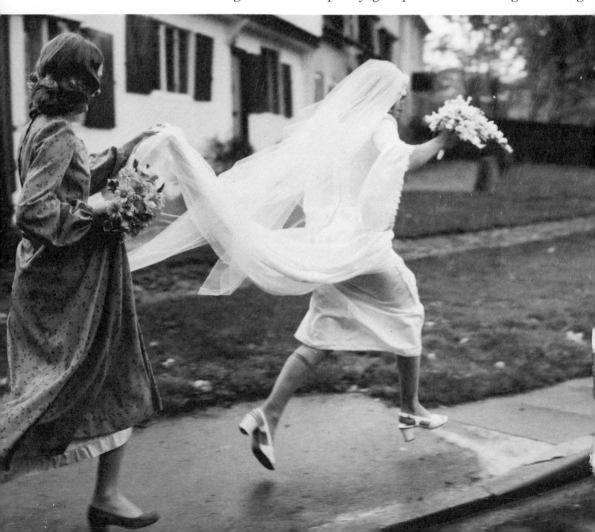

them to say silly words if he can make himself heard above the church bells.

8 Add in the parents on each side. Several shots, smiles.

9 Add in all relations who want to be included. Several shots, smiles.

10 Bride and groom walking down the path if any and getting into the car.

11 Shot with flash inside car.

12 Reverse shot of the guests waving.

13 Cake mock-up if possible.

A photographer should be able to do this quickly and efficiently in about ten minutes after the service. He

The lighting and composition of this picture of a bridesmaid in a church porch was so super that I could not resist it.

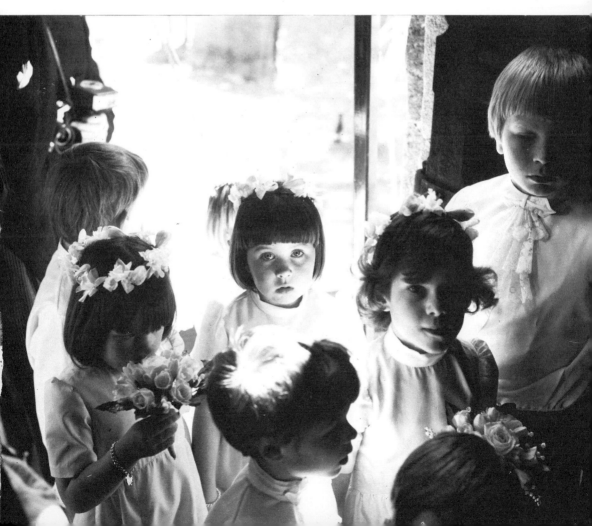

might be able to take many of them while the guests are still inside the church. The amateurs will be furious, but their turn comes later. He does not have to use the church door if there is a good setting in the churchyard without gravestones, which will not look very good in wedding pictures, but the guests will really stream out and inter- fere. If he is really quick, efficient and economical, he might get away with 24 shots for the smallest, cheapest coverage.

Some local photographers take masses more groups and combinations. They try for a ring ceremony picture. They do double exposure techniques and, above all, many take half an hour or more holding up the whole proceedings. I don't think this is necessary in a simple, cheap, straightforward coverage. The only shot I may have missed out is the groom arriving with the best man.

The local photographer will almost certainly shoot colour and on 120 film using two cameras or one with two backs, he will have a tripod even if he does not really need it, to establish his 'claim'. He should be neatly dressed in a suit–no jeans, it is an insult to the bride. He will very often have a flash attached to the camera for fill-in on a sunny day, into the-sun shots or as the main light at a late winter wedding.

Some professionals produce proofs, (which they later might try and sell); with others the proofs always remain the property of the studio. Most present the proofs in plastic albums with reference numbers. Prices—these vary enormously. Anyone starting up should get his girlfriend or sister to go round all the local photographers and ask for quotes and price lists. He can then make up his mind how he wants to do it. There may be a small attendance fee plus a higher price per picture but more common is the all-in deal. 'Coverage and an album of your own choice of twelve 8 × 6 inch pictures for £35,' would be typical. Extra copies in folders for friends and relatives, £2–3. Extra album for brides' parents with twelve pictures, £30. These are some of the sorts of prices I have heard quoted. Growing in popularity are the canvas-bonded pic- tures. I still dislike them!

Not a picture the local photographer would be likely to be happy with! An ideal moment for me and an amateur with a flash on his camera. Winter wedding in a gale! One page boy being un-cooperative! The clients loved it and ordered masses of copies!

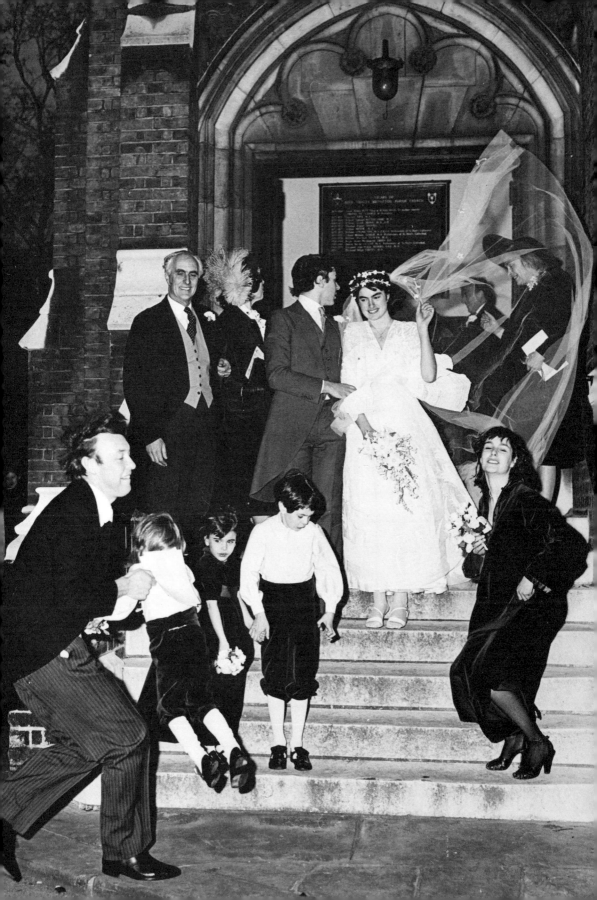

What if it rains?

You can ask the vicar if he will allow you the privilege of using the inside of the church and it sometimes works. The bride and groom can still be photographed in the porch with someone holding an umbrella over your head. The groups will just have to be done at the reception. however uninspiring the backgrounds, with flash, so time must be allowed for this. Many professionals keep a wide-angle lens or camera in reserve in case groups have to be photographed in restricted areas. The best man and bride's father can help get groups together if things get out of hand. I always carry a large golfing umbrella in my car to lend to a bride in case the chauffeur has not thought of it—it often gets used. I heard of someone else who has a large white electronic flash brolly in his car and when he has to take pictures of the bride and groom in the rain it keeps them fairly dry and helps light them as well! It does not matter if you get wet but try and keep your camera dry under your coat or you will not be able to focus through the rain spots on the eyepiece.

If the bride is late

The photographer should not hold her up but shoot all the pictures after the ceremony. It is the important day of her life and she will appreciate help and co-operation. A local photographer should always be friendly and willing to give advice, if asked. He should see the bride before the wedding or ask her to come and see him at his studio, where he hopes she will be impressed with the quality of his work and he can show her the various albums and 'coverages' in advance. I heard of one American photographer who had three coverage rates; a very cheap one which nobody chose because they did not want to seem mean, a very expensive one which they could refuse and an average one which he wanted them to chose in the first place! Good psychology! I have another friend who used to have a white Rolls Royce and act as chauffeur and photographer at the same time. Ingenious!

Many photographers take this over-the-shoulder shot but usually with flash. No flash was used for this one!

128

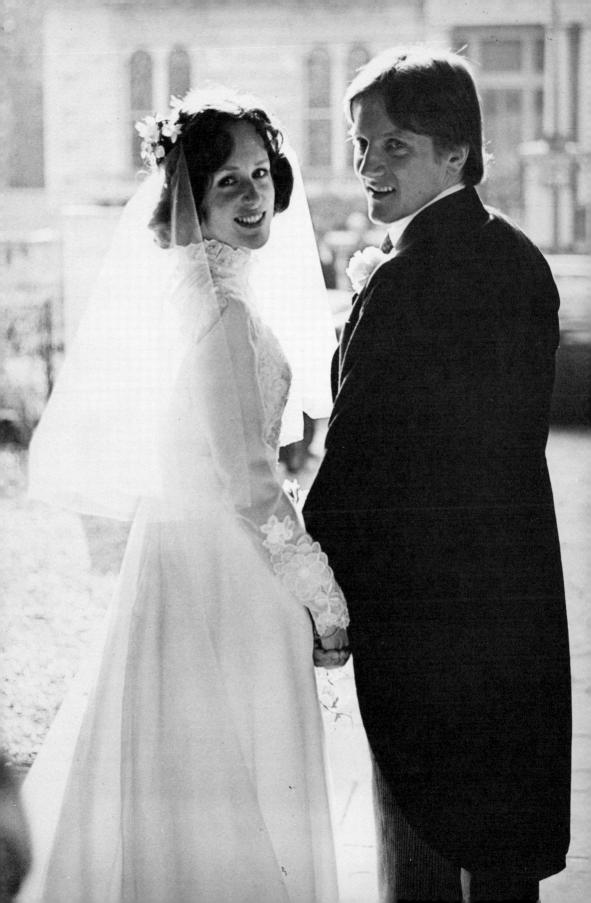

After sales

Either the operator or a highly trained assistant should visit the bride's mother with the proofs and explain the procedure or persuade them to come to their reception area of the studio where they might do a soft sell on the idea of an extra album, a giant enlargement or some frames, all increasing sales and profits as well as providing extra service and help in choosing from proofs which people are notoriously bad at!

What the amateur can do

We can see he has a lot of competition from even the cheapest local photographer if he is anything like I have described—an efficient, pleasant, charming artist and salesman as well as being professional and up to all the tricks of avoiding competition from amateurs. However do not despair! You can see how he only has a chance to shoot the absolutely essential pictures before moving on to the next wedding. He also has a living to make and is responsible to the bride for the best she can afford and he can do. The first and only rule for any amateur at a wedding is: *Do not interfere in any way with the professional unless he invites you to shoot a few pictures while he is changing a reel.*

If the professional is shooting his posed shots, let him get on with it. Don't shout at a group 'one for me, please'. You distract half the group and ruin his and your shots. Shoot the group discreetly from one side by all means, but go for the candids. Depending on how close you are to the family, it's worth suggesting you go to their house beforehand to shoot pictures of the bride and her parents and any family or bridesmaids who might be there. Ask for the bride to be ready ten minutes before leaving time, to give you a chance. Always have an accurate wrist watch. Find out how long it takes to get to the church and make sure they are away on time—don't make them late or you won't be friends for long! The bride should never

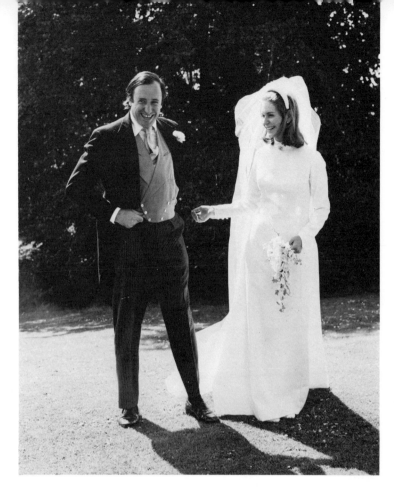

I asked the bridegroom to pull up his trousers (which is often necessary) and could not resist taking a picture of him doing it. They loved it!

arrive more than 5 minutes late. I suggest only really competent amateurs try this.

With experience, you can even help the bride into the car and show her how to sit without creasing her dress. Fathers are usually hopeless at this. If there is time, try an available light picture or flash picture of the bride and her father in the car.

Forget shots in the church unless you know the vicar very well, but if all the guests come out and watch the professional at work, turn your lens on them and you will have some lovely candid groups of the bride's friend's.

Don't bother with the mock cake cutting but do get back to the reception quickly, because you want to be at the head of the receiving line. The bridesmaids will already be there with nothing to do, so take some individual shots of the bridesmaids and children, preferably in a quiet corner or out of doors. The professional is not going to be too pleased if you undercut him but if he is not there he cannot complain. The bridal line receiving is not particularly good for pictures because of the hats and

131

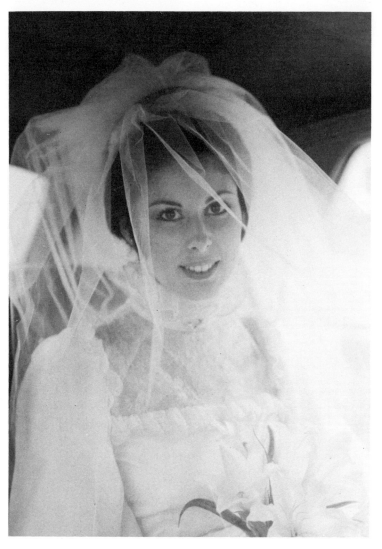

Sometimes one can get a picture with available light of the bride in the car, but watch the creases in the veil!

backs passing your lens, but try for close-ups of the bride greeting an old boy friend, perhaps. A long lens is helpful for this. Cocktail and buffet reception are easier for moving around and finding subjects. Once the formals are over try some shots of the children getting stuck into sticky cakes or tasting the champagne. If they don't do it ask them to!

People generally are not attractive eating so put away the camera until the actual cake cutting and the speeches. Speeches, however boring to listen to, often make good candids and shots of the guests watching are a good idea. Summer weddings are often held in locations where it is possible for part of the reception to be held in the open air. This provides super opportunities for candid shots of the family dog with a ribbon in its collar, Grandpa dozing in

132

A single shot of the cake (in this case lit by the light of an overhead spotlight and time exposed with tripod) is a good idea, because the cake does not always look at its best in the cake-cutting shots.

the shade, character studies of weird guests, a top hat with a champagne glass on it (you put it there) or two young attendants holding hands under a tree with the sun rim lighting their profiles (if this does not happen, organise it!).

The bride and groom will often be happy to give you five minutes of their time after receiving. Use it properly. Be quick, efficient and full of ideas.

At one wedding I did in the country, I knew there was a rustic bridge over a stream at the bottom of the garden near a lake. I checked out camera angles in advance and then asked the couple to spare me a few minutes. They were quite relieved to be away from the guests for a short time anyway. The result was the best picture at the wedding, and one of my best ever. I did it again when her sister got married! In fact, any experienced amateur could have done it and, if I had spotted him I would probably have nicked his idea for a change!

If you were not at the house before she left for the church, the bride might pose on her own for a few pictures.

133

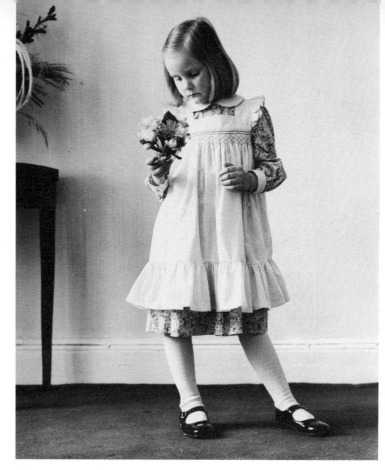

Individual shots of bridesmaids, organised and not, are a must and a good seller for the professional. There was enough daylight in the room for me to be able to shoot this with camera on tripod and no flash.

These must be set properly with the train and dress neatly arranged and the bouquet not too high or too low (the arms slightly bent is about right).

You can use the trick I told you about with the couple walking towards you while you walk backwards across a lawn, with their backs to the sun and dark foliage where possible (don't forget to use a fast shutter speed). They can be joined by the pages and bridesmaids if they are around. I call it a 'walking group'.

Weddings are a marvellous opportunity to try out your child photography, both candid and organised. Only resort to flash fill-in if you really have to and then only for full-length and keep that flash at half power. (With automatic guns set the film speed to 1 to 2 stops faster than the one you are using and make sure the aperture setting on the flash is the same as the camera.) Overuse of flash gives very unnatural-looking results, as seen in the work of many bad wedding photographers.

I am always on the look out for unusual angles. I noticed the bride's father watching as I was trying to arrange the bride's veil.

All parents are only too keen to have (and buy) good single shots of their offspring looking smart in their wedding gear, but the pictures need not be formal. Small boys

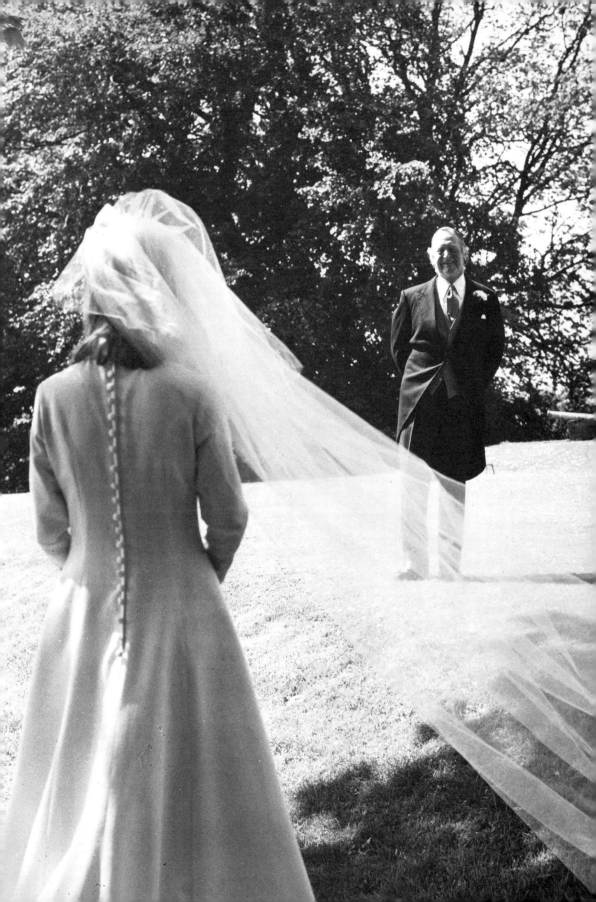

can peep round tree trunks. Bridesmaids sit on the grass with their dresses spread all round them. You, as a guest, probably know the family better than the professional. Pick out old relations and get in close. Elderly grannies are seldom photographed, so this is the time to extend the family records. (Even if they have been a small part of the professional's pictures at the church.)

It does not matter, as an amateur, what camera you use. Most of the above ideas will work with simple cameras but the blow-ups will not be so good. Don't shoot into the sun without a lens hood.

With the advent of 400 ASA negative colour materials there is no reason not to have a go in any lighting conditions but I find that they are rather high in contrast for use in full sunshine. If it is obviously going to be sunny, use the slower colour negative film, such as Kodacolor for

This going away shot was taken by my wife at a wedding I was shooting. Although they liked the whole set, this was their favourite picture! You can't win 'em all!

35 mm cameras. I use Vericolor II most of the time only resorting to Kodacolor 400 in overcast conditions. (It is ideal for shooting inside churches!). Don't spoil results, especially if you have a good camera, by sending them to a second rate processing house. A professional lab many offer a good package deal for wedding proofs on 120 but not 35 mm, which comes out quite expensive.

If you have done everything I have suggested above, what a wonderful wedding present for the bride to supplement her official pictures! If you are asked for extra copies from people you do not know, charge professional prices. It is only fair to us and you will recoup some of your expense.

There is one thing you must *not* do as an amateur and that is take on the responsibility of the picture taking for the whole day whether or not for a fee. It is not as easy as it looks and you do not have the back-up service and time to take to organise and sort orders. Of course, if you are keen you will have a filing system but please, for your own sake, don't *do* a friend's wedding to save them money. It will not, because, if you are responsible for the official pictures and you let them down, you can never replace the day. Becoming a professional is another matter, but if you are in a well-paid job keep your wedding photography as a hobby.

How I do it!

I have photographed over 1200 weddings professionally and am self-taught. I do all the things that I have described the local photographer doing, but seldom working much at the church; more the groups at the reception. I also try and do what I have suggested that amateurs do at weddings! Why? I want to charge more, and cover the whole day right through even to the going away if necessary. I am a national photographer as opposed to a local photographer and I work, mostly, for people who appreciate good photography. Sometimes I am let down because they want me for my name and not my work, or because I

137

Gary Glitter was the best man (right) at the wedding of Mike Leander to Penny Carter. Obviously it was important to get some good shots so I found a bottle of champagne and I did a close group for them and the press.

misjudged a client or a location. The other thing which will astound most of you is that until late 1978 I used a lot of black-and-white film for weddings! Now my normal coverage is about 60 pictures in colour. Because of the introduction of 400 ASA colour negative film I can do all my unusual pictures for which I previously had to use Tri-X. If only colour is wanted I try and cover it on 48 shots but it does limit my candids and experimental shots. At one recent wedding I tried some colour silhouettes, which I love to do in black-and-white, and the labs did not even print them as proofs because they thought they were mistakes and my flash had gone wrong!

I shoot as accurately as possible and try never to tilt the camera, so that I can use 'machine' prints. No, I do not even want to know how to print colour; I just know what I want the results to look like. I do like offbeat wedding pictures, but only in addition to the important ones and even with these I am not happy unless they look happy.

I always try and go to the bride's house to do pictures

138

before she leaves for the church. I have already talked, or my wife has, to the mother or girl on the phone. They have filled in my 'details' which is, in effect, a contract as well. They have booked me because they already know my work, or because I have sent them through the columns of engagements in *The Daily Telegraph,* a letter photocopied but personally signed with a black-and-white, simple brochure.

My minimum order at the time of writing is 50 pictures per wedding at £4 or £5 per copy plus VAT and expenses depending where the wedding is etc. I love weddings and get very personally involved with some of them. One gets to know people very quickly in my job. I have had two letters recently. A bride's mother wrote to me and told me I had been such a help organising her husband and daughter before they left for the church, that when her next daughter gets married I must be there to 'get them over the starting line'!

Another wrote to me before seeing the proofs and thanked me for being such a calming influence on all of them before the wedding (they invited me to their lunch before) and helped them through the day with no fuss or bother. She also added that a very observant friend of hers had written to her and said what a lovely wedding it was but why were no pictures taken! The answer was that the guests never saw me take the formals or noticed me sneaking about the reception (out of doors but some with flash in the marquee). This is my style when possible. I try and fit in and become an instant friend of the family. At the reception I fit in as a guest who is taking a few snaps. Why? Because it is the bride's great day and I try and help it along and not get in the way. But how?

In the latter case I did all the bride singles and the bridesmaid singles plus pictures with father and mother before the church. At the church I only recorded the arrival, the atmosphere of the service from the back of the church in the first hymn, the bride and groom coming out, (lovely pictures of them all walking to the cars), (the guests were still inside the church, so no hope for ama-

teurs), straight back to the house, which was nearby, and through the house for groups in a prearranged place in the garden. The guests who arrived early were held back and given a drink in the house but they did not have to wait long. The formals were all over in a flash (or without a flash?). I waited until the cake cutting and speeches and shot them with plenty of views of lots of guests watching (it is the only time they are all looking the same way). After the cake cutting and speeches, I took all the ushers into the kitchen garden and did some crazy usher groups. After that I took candid and organised groups of the father and his two rascally brothers and others. They did not want the 'going away' done. So I went home, exhausted.

I don't make a fortune, (how many photographers do?), but I do get terrific 'job satisfaction' particularly with the letters that arrive after a good well-done job—I even had a letter from a couple on honeymoon in Kenya, who wrote and said thanks (before seeing the pictures) and organised a bottle of champagne as a present for me through the post as a 'Thank you for helping us through the day'. *That* I really appreciated!

Money does not motivate me as much as it should! Giving great pleasure gives me *great* pleasure. It sounds very generous but it isn't. It is what keeps me going professionally. Just as a comedien thrives on laughs and an actor on applause.

In the early days I did many midweek weddings in the big London hotels, such as the Hyde Park Hotel, Claridges, The Dorchester and the Savoy. These seem to be dying out because of the prices they have to charge I suspect and weddings are now mostly on Saturdays in the country at or near the bride's home. Photographically it is more interesting but I dislike travelling. Believe it or not, I often ride in the bride's car driven by the chauffeur and back again afterwards—some of the drivers are horrified. It means I can be on hand all the time to take pictures and help the bride if needed. You could almost say that; apart from the informal formals, I cover a wedding photojournalistically. The idea of the order forms I send

Sometimes something happens after you have finished a formal family group (or you make a remark about the dog) which 'breaks up' the group into laughter. Always have a couple of shots left to catch it!

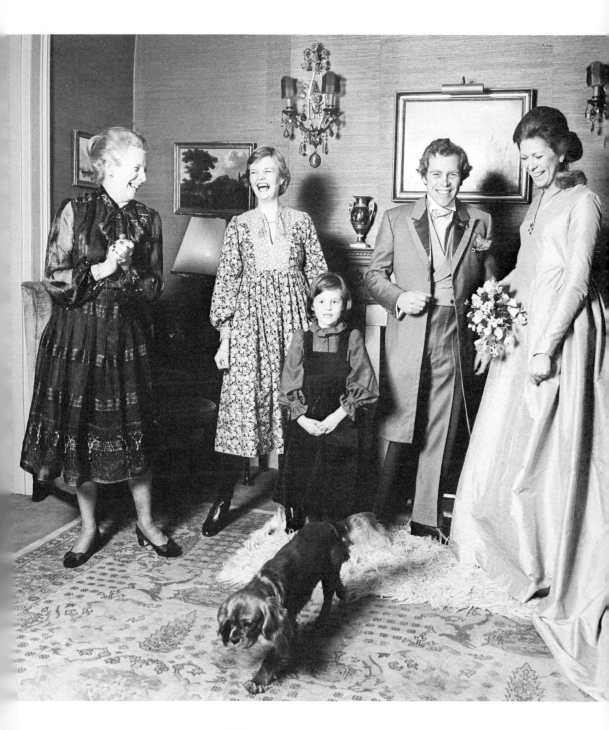

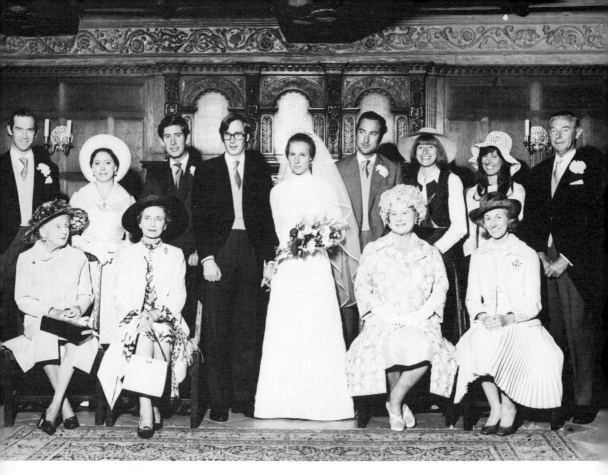

Eight Royal Highnesses and One Majesty in a group. How do you cope?

with the proofs to the bride's family is to help my turnover on a wedding to average out at about £300 each.

I have done two Royal weddings, Lady Pamela Mountbatten to David Hicks where I was only commissioned to do the group which contained all the members of the Royal family except the Queen. Luckily Lord Mountbatten organised the placing of that, since it was huge and I was too inexperienced to handle it, and more recently Prince Richard of Gloucester to Birgitte van Dorens. In this group there were eight 'Royal Highnesses and a 'Majesty'. At one moment I wanted one of them to raise their chin, so quite correctly, I said, 'Your Royal Highness will you put your chin up please?' and *nine* Royal chins went up!!

Talking of etiquette, there is nothing written down anywhere to guide us except the usual 'Your Royal Highness' or 'Your Majesty' when you are introduced or the first time you speak or are spoken to followed by 'Sir' or 'Ma'am' thereafter.

At one wedding in St James's Palace, where one gets written instructions beforehand about every detail, The Duke of Edinburgh, The Queen Mother and Princess

142

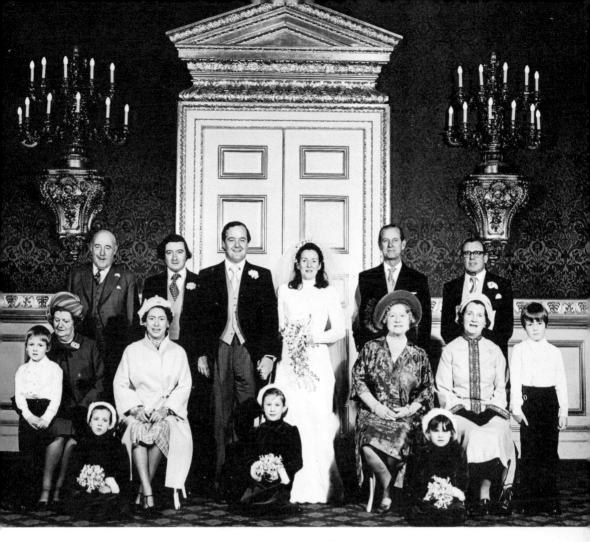

A wedding at St. James's Palace. What happened?

Margaret were in the group which I had to take. I was introduced to the Royals by the bride's mother, held a short conversation with them until the attendants arrived, placed the ladies and children and then said to Prince Philip 'Would you mind joining the group, sir, and stand next to Annabelle (the bride)'. He said he was not sure if he or her father should stand there and I got a bit panicky and 'Sorry guvnor, but in my groups *you* stand next to her'. He looked a bit taken aback, because one thing one should *not* do is call Prince Philip 'Guvnor'! Anyway I think he forgave me, because he co-operated perfectly after that! The Royals have attended so many weddings they know the form as well as I do and always appreciate speed and efficiency.

At another wedding where the Queen Mother was present, she came up to me afterwards, shook my hand and thanked me for doing the groups nicely then turned

and held out her hand to my assistant. He was surprised but shook it. Afterwards I noticed him standing looking bemusedly at his hand and asked him what was wrong. 'I am not going to wash for a week', he said!

Yet another time I turned up at what I thought was going to be an ordinary country wedding. When I arrived in good time before the wedding, it looked a lot 'posher' than I thought it was going to be. I asked the caterer if there was anybody special coming. He said 'Yes, The Queen and Princess Margaret'! It took two glasses of champagne to revive me. The bride really should have told me.

Don't get the idea that all my weddings are like this. I do everything from these grand affairs to registry office weddings, Jewish, Greek Orthodox, the lot.

At long distance country weddings I often travel up the night before and use the morning to study the church and reception area. For weddings two or three hours away I set off early leaving time at the other end for lunch plus an hour to spare for punctures etc. The one thing one must *never* do is to let down a bride by being late or not turning up.

I am always on the look out for offbeat, funny and unusual pictures. I never take private commissions or money from guests. Occasionally I meet a friend of the bride who says, 'Can you do a few pictures of my children?' I always ask if she will see the proofs because I cannot separate them. If the answer is 'Yes' I shoot a few pictures. At one wedding I did an 'engagement sitting' of a couple sitting on the lawn and got a splendid order!

I would like to raise the reputation of the wedding photographer from the 'flash man at the church' to that of a good 'commercial artist'. Because the standards of amateurs are rising all the time, I know other professionals are trying too. We have to keep one step ahead.

The Queen was at a wedding with Princess Margaret in the country. I had not been told. Imagine my surprise!

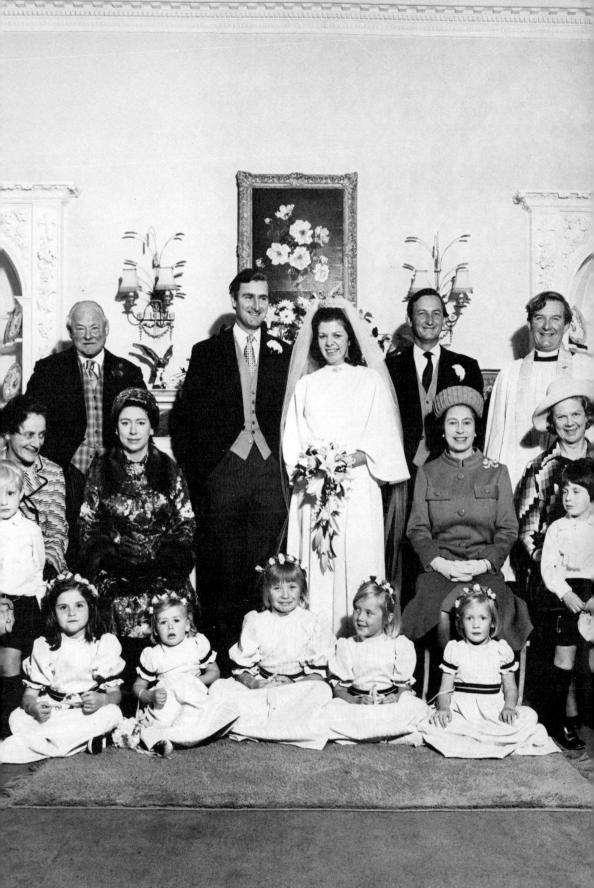

TOM HUSTLER LTD

KYLEMORE HOUSE, THE WARREN,
MAPLEDURHAM, READING, BERKS.
RG4 7TQ
READING (0734) 475804

Dear Miss — — —

Having read of your engagement in the papers, I hope you do not mind me writing to you about photographing your wedding. (I have done about 1250!). I now photograph them all personally, so can only do one a day!

Coverage is from the bride before leaving for the ceremony to the cake cutting and speeches, including some informal groups, bridesmaids and pages taken individually and any guests and relations you ask me to take. (It is best if you appoint somebody who knows them for this task, to help me find them.).

I also try to get some 'crowd shots' during the speeches, when all the guests are facing towards the cake.

Since the introduction of a new super fast colour film, I now do an all colour coverage. I do not charge an attendance fee as such, but need a total combined order of 50 pictures at the prices per copy set out below. This is not a difficult number to achieve when you consider that you will need a set; both sets of parents and various other friends and relations, including the bridesmaids and pages families, will all want pictures which they can order individually on our order forms (minimum order per form is 3 pictures). I charge 5p per mile and possibly bed and breakfast (about £10) for long distance weddings (over 50 miles from Reading; there are therefore no expenses for London weddings.

The proofs remain our property by law and must be returned with last orders, which should be within three months of receiving the proofs. I take about 60 shots to give a full coverage and make a point of working fast and un-obtrusively, in order to help the day go as smoothly as possible. We shall be happy to give you 5 10x8 pictures of your choice, if you can help us get the total combined order up to 80 pictures.

My prices per copy, chosen from proofs, are as follows:-

10x8..£5 8x8, 8x6 or 5x5(proof size).. £4.

VAT is added at the current rate (8% at the moment).

If there is anything you want to discuss please ring me or my wife, Mari, at the Reading number. (I work from home and travel to jobs all over the country.)

Yours sincerely,

Registered in England
Company No. 382651 DIRECTORS: TOM HUSTLER MARILYN HUSTLER E. W. HILLIER

Approach letter.

Date...................

To TOM HUSTLER, Kylemore House,
The Warren, Mapledurham, Reading, Berks. RG4 7TQ
Tel. Reading (0734) 475804.

Dear Mr Hustler,
I would like you to photograph the following wedding and these are the details:-
Date of the wedding...
Name of Bride...
Bride's parents and Address.......................................
..(Phone)..............
Name of Bridegroom..
Bridegroom's parents and address..................................

Pics before ceremony at......................at....pm
Ceremony at..................................at....pm
Reception at.................................at....pm
There will be approx......guests.........bridesmaids and...pages.
I would like you to take mostly colour/mostly black and white pics.
There will not be another professional photographer at the wedding.
I would like the proofs sent to..................................
..
Special instructions, requirements, etc...........................
..
..

I understand and agree to your terms and prices as listed in your Wedding Price List.

Signed...........................
Name.............................
Address..........................
..................................
..................................

Details from contract.

ORDER FORM

TO TOM HUSTLER LTD., KYLEMORE HOUSE, THE WARREN, MAPLEDURHAM, READING, BERKS. RG4 7TQ. Tel. Reading (0734) 475804.
When ordering from black & white contact sheets, it is the number above the picture that counts. Also please do not order black & white from colour proofs or the other way round!

Please supply the following pictures from job No.............in/not in folders at the sizes and prices below.

COLOUR Number of copies					BLACK & WHITE Number of copies				
Neg No.& Letter	10x8 £5	8x8or 8x6 £4	5x5 £4	Value £	Neg No	10x8 £5	8x6 £4	5x5 £4	Value £

Total before VAT £	Total before VAT £
Please add VAT at 8%	Please add VAT at 8%
Total including VAT £	Total including VAT £

MINIMUM ORDER PER FORM 3 pictures

Combined Total £ _____

(BLOCK CAPITALS PLEASE)
Please send order with/without bill to
..
(Please enclose cheque) Signed...................

Order form.

My method with weddings.

I contact brides-to-be through the engagements columns in *The Daily Telegraph*, with the letter and a printed folder of black and white pictures. About 60% book because of this and the other 40% through reputation and recommendation. Once they have rung me I send them a form to fill in which gives me the details of the wedding and also acts as an informal contract. When I send out the proofs, which remain my property and must be returned, I enclose 6 or more order forms, so that members of the family and friends can order separately, enclosing their own cheques. These have to add up to £200 by my price list but most weddings go well over this figure. Notice I do not charge an 'attendance fee' but a 'minimum order'.

16

Advertising and Fashion

I have never been very good or successful at these two branches of photography, although early on in my career I did try very hard to learn. I could not understand the reason for this for many years, and then I began to realise that there was more than one.

Firstly, I am a photographer of people and the most important things in fashion and advertising are the products. You may say that in fashion the model is important. She is, and is responsible for 50 per cent or more of the success of the picture, but basically she is still a girl modelling a product. In the fashion pictures I did do, the girl tended to be more important than the garment!

Secondly, I am a loner and like to be entirely responsible for the results. I never was a good team man. I hated advertising art directors, clients and others breathing down my neck on a session—all having their say. I have done some successful advertising jobs but usually the only good ones were when I was given a brief and left to get on with it! There was one agency that asked me to photograph a country gentleman standing in front of a stately home drinking a cup of tea! I 'borrowed' a beautiful country house from some friends, hired a good male model who I knew could look like a tweedy country gentleman and we all had a good laugh but it worked! Another time I was asked if I had on file a picture of a man rowing sculls smoking a cigar! People don't smoke cigars when they are rowing! I said I could try shooting it with a model but was not asked to. I heard later that the art director tried to shoot it himself and it was a disaster! It poured with rain and the model fell into the river. In the end they used the usual 'pack' shot.

Patrick Lichfield once said that all the advertising photographer has to do is to translate the art directors sketches or ideas into photography! It is true most of the time. Another time we were discussing the judging of a photographic competition and he said that he had been trying to do some original shots of jewellery and had been photographing rings on vegetables including carrots. He

suddenly realised that anyone with a remotely vulgar sense of humour would find them very funny—the idea was scrapped!

Thirdly I already had a name for being a society or debby photographer so although I had quite a good portfolio, and had showed it round some of the art buyers the advertisers did not believe I could shoot their type of work.

Fashion photography has changed since the 1950's. Then in the days of John French taking pictures of Barbra Goalen and Fiona Campbell Walter (now Baroness Thyssen) the emphasis was on elegance and every detail of the dress mattered. It still has to be like that for catalogue fashion photography. Then in the fashion magazines at least, the change was to 'mood' swirling out-of-focus grainy pictures in which you could hardly tell whether the girl was wearing a ball gown or a bikini. The reason for this was to make the feature pages more interesting and not like a catalogue. Now there is a happy medium and there is more of a tendency to shoot nice clothes in natural surroundings. One still sees the occasional evening dress floating over rugged countryside, but I like to see girls in casual outdoor clothes striding across a gravel pit.

The newspapers have a more difficult task because they print on poorer quality paper but *The Daily Telegraph's* pictures are always smart and elegant as are those of *The Times*. Some newspapers use staff photographers who have specialised in fashion. The best of these in my opinion is Chris Barham of the *Daily Mail*. I was one of the judges in a national competition for press photographers and I persuaded them to give his picture a prize without realising it was his!

A word here about modelling. Mums, please don't push your daughter into it just because she is pretty and all the neighbours say, 'Cor, she should be a model'. Of course, if she is really determined there will be no stopping her. A model has to be a tough, thick-skinned cookie! She has to fight to sell herself and be a good business-woman, because she *is* a one-person business. Most, in

Shot for Brooke Bond Tea (Belgium).

148

these liberated days, are expected to take all or most of their clothes off at some stage, even for fashion. The top girls are very professional and have fought hard to get there. If you don't believe me, send a prospective model to Leslie Kark who runs Lucy Clayton's modelling agency. He'll tell her the chances of success and the truth! The best way to start is modelling head shots and nothing-less-than-bikini shots for amateur photographic clubs. Learn about make-up and control of hair. When you have persuaded some of the amateurs to give you some pictures, start a portfolio. Enter local beauty contests. You will soon find out what a rat race that can be. I have helped (and been thanked later) far more for putting girls *off* modelling than encouraging them!

Photography as a profession became very 'in' the 1960's. It is very overcrowded, particularly in the fashion and advertising field. Why don't they try to be really good wedding photographers instead? Perhaps they do not own a suit!

17

Glamour Photography

This is usually defined as pictures of pretty girls, looking their best, or better than their best ('glamourising' them). Various types of glamour photography are used in newspapers, men's magazines, calendars, record covers and all forms of advertising. In this chapter I will try to describe a little about the basic technique. When this is mastered, the reader can adapt it to his specialty. Success depends on the skill of the photographer and the looks and professionalism of the model. For instance I used to concentrate on newspaper glamour and pictures for worldwide sale through an agency as record covers and for other commercial uses. The first market was closed to me by the unions on the big national newspapers who now do their own or use an NUJ member (I was not allowed to join) the second course was not worth doing without the support of the newspaper income. Also it does not mix with marriage!

The professional approach

A professional photographer's approach is straight-forward. He will go to the best agencies and select the best girls for the type of pictures he wants to do. He might ask them along for an audition or to discuss the work he wants to do, and see their portfolio. He will book at an hourly rate and after the session he will get her to sign a model release which gives him the right to use the pictures in the agreed way. A top glamour photographer does not waste time. He has his studio, equipment and props ready in advance. Equally the top model will arrive a little early and put the finishing touches to her appearance, meanwhile discussing the job with the photographer, and be ready to start shooting at the appointed time. They will work together as a team during the shooting, each adding their own suggestions and ideas. The photographer has a props drawer and the model brings a bag full of accessories and change of clothes. They will produce a good variety of pictures for sale to different markets.

151

The amatuer trying to do glamour work should strive for this professionalism. If he hires a studio with a good model he has more chance than with an amateur model in his own environment, but, before wasting money on this he must build up his own skill and experience.

Portraits for starters

Don't try glamour as soon as you buy your first good camera. If you have already gone through the stages and mastered the techniques of portraiture in and out of doors, then is the time to think of looking for a model for a glamour portrait session, which only differs from an ordinary portrait session in that you are using a pretty girl who is made-up, hair styled and posed to look as alluring as possible. *Glamour is fantasy.* No pretty girl in everyday life ever makes-up and then sits in a chair flirting and pouting at you like a goldfish! Neither does she normally stand half naked with one hand on one hip and the other pretending to pull her trousers down, pushing out her chest to show it off and giving the eye at the same time. It is completely unnatural and great fun! I was asked for transparencies of glamorous girls naked or nearly so, playing musical instruments. One does not see many girls lying on the floor naked trying to play a trumpet or a girl in a bikini playing a trombone but the pictures were great fun and sold very well as record and cassette covers!

After trying half a dozen glamour portrait sessions, you can ask the best of the girls you have found to pose for three-quarter and full-length pictures in shorts and shirts and bikinis etc. Concentrate on this type of session until you find a girl willing to pose for semi-nudes or artistic nudes.

Cameras

For glamour a good 35 mm camera is adequate but you will need a standard and semi-telephoto lens with a focal

length of about 70 to 100 mm for the portraits and three-quarter length shots. If black-and-white pictures are taken on 35 mm they must be crisp and sharp with a simple background if they are for reproduction. Transparencies on Kodachrome are great for projecting, and now acceptable by most magazines but I still prefer my standard and Tele Rolleis for black-and-white. The larger format film and superb lenses give technically super results, even on fast film, and they are much easier to print in the darkroom! However a reasonable 35 mm camera with two lenses is all you need to have a go. As with all photography pick one kind of film in each category: colour transparency or negative and learn what it will do for you. When you understand its qualities, you will be able to rely on it. *Don't* chop and change makes of film, unless you are unhappy with the results.

The fewer accessories you use the better. A sturdy camera bag, lens hoods for all lenses, UV or haze filter (plus possibly a polarising filter for darkening skies), a tripod and light meter, if you do not have one built in. Photographers who walk around with a million cameras and accessories looking like walking Christmas trees, often do not take very good pictures! You can keep a projection screen as an outdoor reflector in your car if you like, but it is a cumbersome thing and liable to blow away at the slightest breeze! Anyway if you have to carry your gear and a screen plus the model's accessory bag any distance to a location, you will arrive exhausted! Not a good start! It is better to look for 'natural' reflectors such as white walls or sand or even a baby pocket flash as a last resort.

Lighting

The basic ideas set out in the indoor and outdoor portraiture chapters apply to glamour as well. Use the outdoors as a studio and observe how the light is hitting the subject. Is it flattering? It will not be very glamorous if it is not. A girl may take up a super provocative pose but if

the midday sun is giving her black eye sockets it will not be very effective. Try the same pose under a tree where she is lit softly from the front by a patch of bright sky and she will look terrific. When the sun is lower use it as a halo light and the sky behind you or a fill-in to light her from the front. Never ask a model to look directly into the sun unless she is wearing dark glasses or can close her eyes as in sunworshipping or sunbathing.

So your best glamour studio may be out of doors! On some occasions you will have to shoot indoors. You cannot necessarily rely on the weather. It is possible to use photofloods for glamour but with the invention of the mains flash on the stand and a flash meter to give you perfect exposures every time is what to aim for. Even one fairly powerful one with a brolly will give you plenty of light to cover a full-length or kneeling figure.

A light wall or a projection screen will give you fill-in and if you keep the light above the camera and fairly close, with the model away from the background, the soft shadow it casts will not worry you. If you can stretch to two units, use one as main light and the second as either a hair light or a weaker fill-in. Three units will give you both. It is sometimes better when using a location such as a luxury flat just to use one unit fairly near the camera.

Don't forget that black-and-white photography is drawing a picture with light and shade. The camera only records what you put in front of it. Colour photography uses light and shade but also the contrast between colours, so the lighting can be flatter and softer. It is the same difference as sketching with a black pencil and painting with colours.

It is easier to do full-length shots out of doors or in a location. I used my Tele Rollei to throw the background out of focus, backlighting by the sun. Front light was the reflection off a white wall. I like the guy walking round the corner, it adds contrast!

Backgrounds

These should be kept as simple and plain as possible to start with. This will let you concentrate on the model which is quite enough of a problem when she starts saying 'What shall I do with my hands (arms, legs)'! The more you include of her the more difficult it gets! At

154

least with a plain background you don't have to worry about lights or trees growing out of her head! You will notice that many of my newspaper style glamour shots are cut above the knee. This is not only because I think feet are ugly but the picture shape is more suitable for the two column picture in the press. The mini background is ideal for three-quarter length shots and sitting or kneeling ones but it is a bit narrow for full-length.

One advantage of the free-standing mini background is that you can shine the hair or kick light from above it if you want to. If you are not sure how the lighting is going to look, switch the modelling lights on one at a time to see how the light hits the body. The back light should be stronger than the front or it will not show up, so flash meter readings can be taken one at a time to check the balance.

It really is not worth trying to do serious glamour work with a pocket flash indoors. The model will think you are more interested in her than your photography. Some amateurs fix their more powerful portable flashes onto stands with brollies but although with practice reasonable results can be obtained I think it better to save up for the real thing!

Don't forget to test and see the results from any new equipment or film before inviting a model along. She won't come again if nothing comes out!

Before looking for professional or amateur models, practise taking really flattering pictures of friends and family. I say flattering because that is what glamour is all about. Although women are beginning to flaunt their sex appeal more openly, especially on beaches and in discos, they are usually prepared to 'push it' more for the camera.

A good example of this is the time my wife, Mari, and I went to a beach in the South of France. When she was sunbathing or walking around in the tiniest bikini, she attracted only the normal amount of attention that any very pretty girl would. *But,* when we started shooting glamour poses at the edge of the sea for my camera, with her taking up the usual glamour poses and provocative expressions,

The sun was from the left and slightly behind Gypsie Kemp. There was not enough fill-in from the surroundings so I used a flash on half power to fill in the shadows. I waited until the businessman was in the right place!

156

she had a huge audience!

The point of this is that you may have to ask even your family to take up slightly unnatural poses in order to achieve flattering results. Flattery is achieved by exaggerating good points (ie. eyes, mouth) with lighting, pose and (for girls!) with make-up and hiding bad points (large noses, wide jaws, double chins). A pleasant, happy expression will usually be more flattering than a stern one.

To sum up:

1 Make sure they look as good as possible before they start.

2 Light them and pose them to bring out their best features and hide their bad ones.

Let us take an example. Say you are taking portraits of a 30-year-old relation (female), which is not an easy age,

Glamour portrait of Julie Ege using my basic head and shoulders glamour pose.

because they always think they look younger. Make sure her hair is tidy and, if long, pushed forward (towards the camera) to frame her face. Her eye make-up should be mascara and brown eyeshadow. This will increase the size of her eyes, whereas light or shiney eye shadows can look very weird, especially in black-and-white. The skin should be covered with a light foundation to cover blemishes and give it a nice texture. Lipstick should be natural colour or darker, possibly with a little lipgloss added but never a pale lipstick which looks tarty and makes the mouth smaller! Ask her to wear a simple polo-necked sweater or a shirt. Patterned dresses are too 'fussy'.

Pose her with her shoulders turned away from the camera, which should be on a tripod above the level of her eyes. If she is too tall, find a lower stool or stand on a box yourself! Use your longer lens. Don't forget if you are nearer than about four feet her features may look distorted. Ask her to push her arm nearest the camera forward and hide her other one from the camera. Ask her to straighten her back, lean forward a little and turn her head towards the camera keeping her chin down and her eyes looking into the lens. This should produce a position like the picture of Julie Ege, although she may not be as pretty! This posing will vary between subjects but it is a good basic one to start with. Once you have positioned her then you have to get the expressions in the ways I mentioned in previous chapters, but don't just leave her sitting there as you do your final lining up and focusing. Talk to her all the time even if you are just telling her what you are doing.

Shoot at least half a dozen with different expressions fairly quickly then change the pose to the opposite way round. If she has a good profile turn her head away from the camera until you can just see the far eyelash. If that is good, shoot several. Next pose you can ask her to turn her head back towards you until she is looking at a point on the wall just over your shoulder. This should give you a three-quarter face. The rule here is never let the nose cut the line of the cheek. It always looks odd or distorted.

Try these positions with the other side of her face, moving your main light accordingly. Try moving your main light between shots a little to right or left and see how the light on her face suits her. Lower it to widen the face and reduce 'bags', raise it to thin the face but watch those bags! Try some of her leaning over the back of a chair with her arms folded and then one with her hand to her face.

If it is a nice day, take her out into the garden and try the techniques of my outdoor studio ideas. After you have done about 6 portrait sessions, or as soon as you feel confident enough, start looking for pretty girls who might become glamour models for you, but don't be in a hurry and always analyse your results.

Finding a model

This is often a difficult problem for amateurs particularly outside major cities you should look for a pretty girl with a good figure. She should have some idea of make-up technique and control of her hair, particularly so that she can change styles quickly and easily. This last applies mainly to girls with long hair, but these are the best for glamour anyway. There are various types of girls who might be good and need pictures of themselves: young actresses, beauty queens, young show models from the local stores, girl hairdressers or any pretty young girl whose friends say 'ought to be a model'.

You might spot the face you would like to photograph anywhere but if your approach is too straight, she will be suspicious. Get a simple visiting card printed with your name, address, day and evening phone and possibly the words 'Freelance photographer' under your name if you feel your skill justifies it! Then if you meet a possible model at a party, you can probably get an introduction bring up the subject of photography, give her a card, if she shows interest she may phone you for a meeting, or even a trial portrait session.

You could, at this stage, go to a model agency taking

along some examples of your best portraits of the family, blown up to 10 × 8 inches or more and nicely presented in an album. You can ask them if they will put you in touch with any girls who want to start modelling or any girl who needs experience in front of the camera and some free pictures for her portfolio. If the model agent thinks you are respectable, you may be lucky!

If you are married to someone who wants to help you with your photography, she will be the ideal person to help you find models, but most wives are not too keen on their husbands taking up glamour photography!

Put the word around at work or in the pub or your club, that you are looking for pretty girls for portrait modelling and are willing to give her some free pictures. There are quite a few proud dads and boyfriends around!

A few years ago I spotted a very attractive girl serving behind the bar in a pub. I could not make contact over the bar, so I gave the landlord, who knew me well, a card, asking her to come round to my studio to discuss a possible photographic session. She had never heard of me but the landlord gave me a good reference. She came round and I not only found a super model, *I found a wife.*

Always take it slowly. Don't rush it. The subtle approach is far more likely to inspire confidence in the model.

Make-up

The make-up for a studio and most outdoor glamour work should be more exaggerated than normal. In the days when I sold a lot to the newspapers the reproduction was so poor that the girl could wear two pairs of false eyelashes on top and one under her eyes and in the paper it would look like she had big eyes. The basic rule is the make-up described earlier but a little more for outdoor and portraits and a lot more for full-length. On the other hand for good magazine reproduction competitions and exhibitions 'slightly exaggerated' is the phrase! Small false eyelashes will seldom show if properly applied and well-blended in with mascara. They are tricky things to

apply and have gone out of fashion for general use, so I would only ask the girl to try them in the second sitting and practise with them in between. The lips must show up well and again the girl may have to practise but she should try to draw a discreet line round the shape of her mouth (or slightly larger) and fill in with a darkish lipstick. There is no need for 'shading' cheekbones because if you put the light to one side it will look as if she has a bruise on her face! For black-and-white pictures the eyeshadow should still be brown and possibly a little lighter colour blended between that and her eyebrows, which should be plucked tidily.

This is a highly exaggerated make-up but illustrates the important features to emphasize, the eyes and the mouth. This was shot during a demonstration of this and the only eye and mouth makeup used was a black lipstick! (Cropping note. The face was placed to the right because this was designed as a 'hair fashion' picture.)

The make up for this glamour head shot was heavy but carefully applied by the model. Heated rollers were used to give the hair more body.

Hair

Heated rollers help a lot here to give the hair width, body and 'bounce'. Let her mess it about and try different ideas during the sitting. Backcombing makes it look wider and thicker.

Direction

It is up to you to 'direct' (as a film director would) your model into poses, the mood and facial expressions you want. They may not be the same as taking a good portrait likeness of Auntie Flossie! You will find this difficult at first. You may feel you know what you want but don't know how to tell her. She may be as awkward and shy as you are! The best way round this is to explain to her what you are trying to achieve and discuss it with her. You have to keep chatting to her anyway or she will freeze.

Use the pictures in this book and discuss the poses with her. Better still, before attempting 'glamour' start keeping a scrapbook of pictures you like in the papers and magazines. You can try the silly word technique and it will work part of the time. Go through the scrapbook with her suggesting this or that pose and expression. Get *her* involved in the project, which is, of course to take a glamorous portrait of her. The expressions are all important—they should be natural-looking but alluring and attractive. There is most of the expression in the eyes which is why I concentrate on them so much, but don't forget the mouth. If she is looking into the camera, in the final picture, she will be looking at the 'viewer'. Talk to her through the camera and tell her that you *are* the camera and to respond to you through it!

Give her a rest occasionally and never ask her to hold one pose too long. Use the gap to change the idea and lights, but keep chatting and telling her what you are doing and why. It works!

After you have taken successful glamour portraits of about half a dozen girls, you should have built up enough skill and confidence to move on to the next stage. You will have a good idea from the reaction of the girls during the sittings and their comments on the results, which ones might be willing to help you get some outdoor bikini shots or indoor glamour pictures. You will find that they are more likely to be willing to wear a bikini by a swimming pool or in a garden, than indoors.

Ideally your first session should be outdoors. She should bring along a variety of clothing from swimwear to shirts and shorts. High boots look good with shorts, and shirts can sometimes be pulled up and tied under the bosom to show a bit of bare tummy! As soon as you have to photograph the whole figure, you will have far more difficulty with directing her, because you have to tell her how to stand, what to do with her hands, which way to twist her body and her head when to bend a knee—in fact everything. This is where the posing scrapbook will help. Take another look at my pictures. You will see that

This girl walked into the studio wearing no make-up and wanted glamour head shots for acting. An hour later she walked out of the dressing room looking like this, much to my relief!

the body is never straight. In the three-quarter pictures there is always a swing to the hips or a leg crossing over. Knees can look very ugly, so I often cut the picture above them. If the legs were not crossed they would look like two stumps, in side shots the leg nearest the camera is bent forward. It may seem that the model has to be a contortionist, and it is nearly true. Glamour poses are meant to *look* reasonably natural but, at the same time be provocative by showing off the girl's figure in the best possible way. Outdoor pictures look more natural, but are just as organised and directed. A girl climbing, dripping wet from a swimming pool wearing a bikini can look attractive sexy and natural, but if she is wearing a thin wet shirt which clings to her breasts and is smiling seductively into the camera, it may not be natural but it would be a much sexier and more suggestive picture.

Glamour photography is a sort of fantasy for the viewer of the pictures. Any normal male enjoys looking at pic-pictures of pretty girls. They may be out of reach and he may never meet a girl who looks like that, but he can always hope or dream about such a meeting. That is what sells the newspapers and magazines that use these pictures.

It might help to tell the model she is really acting the part of a sexy spy for your camera (not you!)!

It is impossible to describe in words every possible pose.

Each girl is different and will look different from the next one and will look quite different even posing in exactly the same way. Some poses will work for some and not for others. In my studio I usually start with asking the girl to face towards the main light, while turning her bosom away from it, and her hips towards it. The knee on the opposite side to the main light is raised by lifting the heel and swung over in front of the other knee. The hands are kept down by the sides with the arms slightly bent or the thumbs tucked into the top of the trousers or shorts.

Painting with light and shade. I have 'clothed' Mari with shadow.

It is difficult to describe in words even one posing position so the answer is to use your scrapbook and my

166

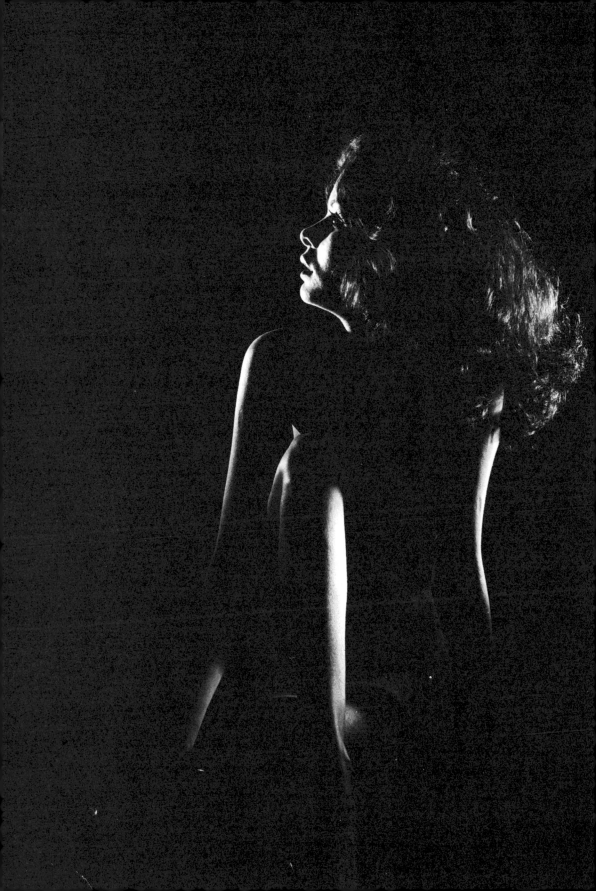

pictures, go through them together, discuss which ones to try and copy the basic poses. After the first couple of shots on each one ask her to vary it a bit ('Left hand up a bit', 'Head to the left a little', 'Knee across a bit more'). Use each pose copied from a picture as a basis for your own ideas.

Posing her outdoors is easier, because you can use natural props. Lean her up against a tree, a wall or a lawn mower. On the beach you can try some kneeling shots at the edge of the sea with her knees apart, her hip pushed out sideways and her hands behind her head, or she can half sit on a breakwater. In gardens and parks, trees are useful props. When she realises what you are trying to get, she will probably start suggesting ideas and variations of her own.

Hands

These can look very ugly if they look too large. The way to make them look elegant is to keep them turned sideways. If the model has good hands and nails I often get her to put her hand up to her face with one of her fingertips placed in the corner of her slightly open mouth. It often produces a lovely cheeky expression.

Outdoor lighting

This is as for portraiture in most cases. When the sun is out and strong, try and find a location where you can shoot her against the sunlight but frontally lit by a reflective surface such as a wall. If there is no such surface in the beautiful location you have chosen, either expose for the shadow side or use a small electronic flash as a fill-in. This must be held close to the camera so that it does not make an obvious shadow.

Bottom shots!

Some girls have particularly attractive bottoms! In the shot of Vanessa Brooks, I turned her sideways to the

This pose of Julie Ege is a good basic glamour position whether against a plain background or walking out of the sea. The main light is over my left shoulder. Her bust is turned away from it. Her left knee is raised and pushed over towards the middle. Her head is straight into the camera or could be turned a little more towards the light. The arms hang loose and slightly bent. The hands are sideways to the camera.

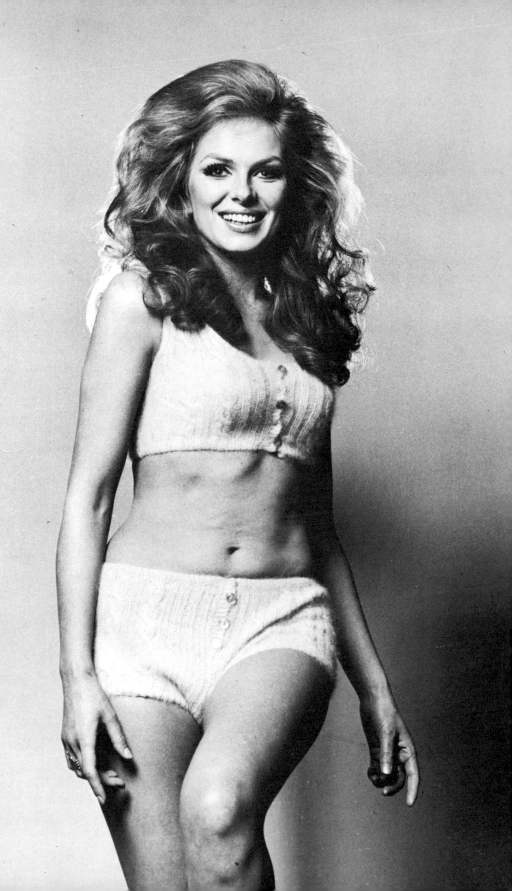

camera and moved the main light around to the right. The kick light was still a little behind her (!) on the left, kick lighting her back. This shot was published in *The Daily Mirror*.

Analysing lighting

Go through all the pictures and try and work out how the lighting was done. The shadows should tell you. A sharp shadow means that a spotlight was used; a diffused shadow means a soft light source. Look at the nose shadows to see how high or low the main light was. The highlights in the eyes are another good guide. If there are two in each eye, then a fill-in light was used. Some people retouch out the second highlight but I usually don't. You can learn a lot about lighting from analysing other peoples pictures.

Model release

Whether you pay a model or not, and you want to exhibit or sell the pictures, you must get her to sign a form of model release. This can be a simple typed statement saying 'In return for £x (or X free pictures) I give permission to use the pictures taken on (date) for editorial use'. There are forms available from some clubs but they are not really necessary.

Be prepared

Before the model arrives for any session, have your basic locations and lighting set-up worked out in advance. Start with a few head shots as a warm-up and leave the cheekiest pictures until the end!

Hiring a studio

In this photo Debbie is wearing one of the 'studio' wigs I used to have for making glamour girls look different between shots.

I have mentioned before that you should not hire a studio until you are sure you will not be wasting your money,

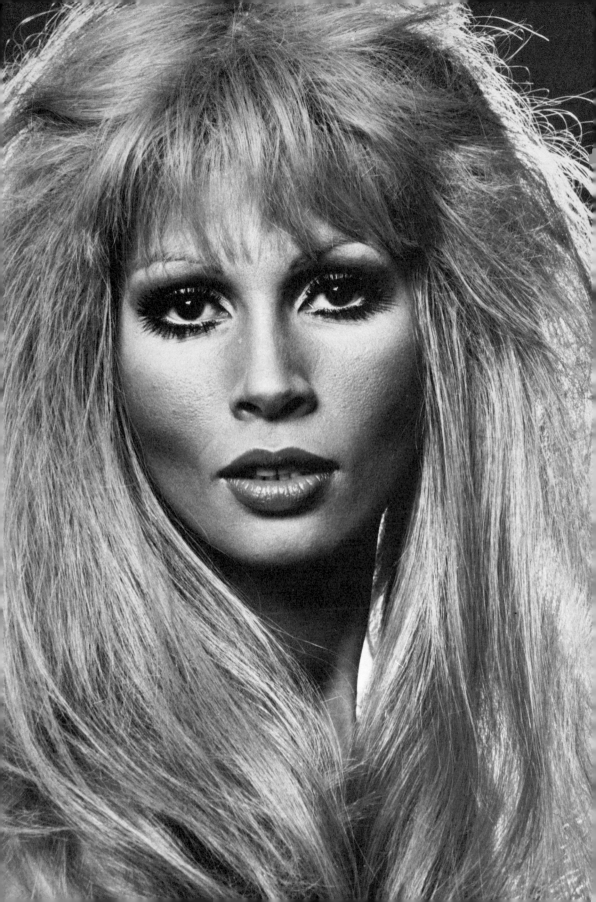

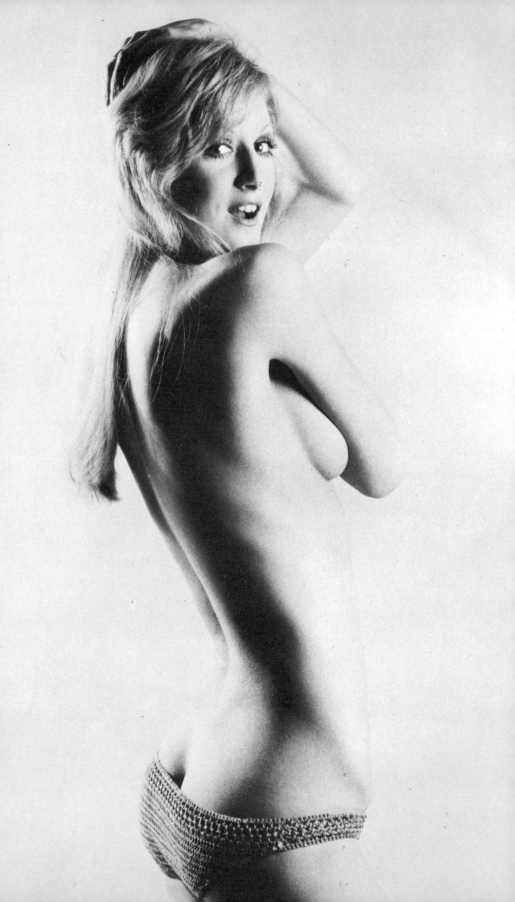

Make-up, hair and pose were organised to make the best of Valli Kemp's features. You can see here a good example of my 'chin down, eyes up' idea of posing.

but I must tell you of the experience of an amateur photographer in Glasgow. He wrote to me as follows: 'I rented accommodation from a photographer advertising in a photographic magazine, who had an extensive studio and outdoor location. He also found me a model. She was quite attractive, but her experience centred around Mayfair/Fiesta-type posing, which was not my idea of glamour and the venture was not all that successful. It rained most of the time too.' Let that be a lesson!

Other sorts of glamour

Although I have concentrated on the basic newspaper style of glamour photography, there are people who might prefer to shoot glamorous fashion-style pictures. The basic technique is the same, but the posing less provocative and the eyes don't always look into the camera. The garment is more important than the model!

This 'bottom' shot of Vi Brooks, was published in *The Daily Mirror*. Not many girls have this shaped spine and back!

173

Semi-nudes and figure studies

Do not try unclothed pictures until you have mastered clothed pictures! The more a girl takes off, the more difficult it is to get good pictures. Nudity is not necessarily glamour.

The unclothed body can be far less attractive than the semi-clothed. The (p. 167) picture of my wife, Mari, is an artistic nude shot, but I have 'clothed' her with shadows. I used two spotlight electronic flashes from behind (one each side) to give a double rim lighting effect against a dark background.

About ten years ago, Frank Selby, of Rex Features, who markets glamour pictures all over the world, told me he went to Japan and his agent over there told him 'We can sell almost any sort of nude picture, as long as it does not show the Public Hair'! (In fact they still cannot by law. There is a factory of 400 Japanese ladies, whose work is to block out all the pubic hair on imported magazines!) I must admit I draw the line in the same place! As far as I am concerned at that point it stops being glamorous.

Artistic figure studies might do well in competitions and exhibitions of photography, but do not sell to the press.

I have to assume, from now on, that you have found a model willing to expose all or part of her naked body for your camera.

Start by asking her to expose one or both breasts, peeping through an open shirt, possibly by a bright window. Ask her to do some 'cover up' poses and then gradually try poses which show more and more.

The old Pirelli calendars did beautiful pictures of parts of naked ladies, and the best, in my opinion, were the edge-of-the-sea shots. The girls were suntanned all over and covered in oil to make the water form droplets on their skin. Those were really glamorous nudes.

I really cannot tell you how to do the semi-porn men's magazine type picture. If you want to have a go the only answer is to buy the publications and fill your scrapbook

A rather imaginative pose? Suggestive without showing anything. Don't ask her to hold it for long!

with the sort of pictures you want to take. Start the session by copying the poses and take it from there!

Selling

At some point in time you will think that you have some shots which might sell to the press. A lot of photographers shoot glamour with only selling in mind. The most important part of selling is *market research*. I have basically prepared you for this by telling you that you must make up a scrapbook of the type of picture you want to do. This scrapbook will also tell you which publication buys what type of picture. It is worth investing in every so-called 'glamour', 'pin-up' and 'men's' magazine you can find. Also buy weekly tabloids and the newspapers which use glamour shots. You will find that some newspapers want newsier stories and captions than others. The show pages use glamour girls, but they have to have appeared, or be about to appear, in a TV series or film, however small the part.

Men's magazines

The titles of these come and go and change all the time. Many seem to compete with each other in becoming more and more pornographic. The largest stock is usually carried by street traders and corner shops. Names to look for in, what I call, the soft porn market, are *Playboy, Men Only, Mayfair, Penthouse,* who all use colour but it must be highly professional and some magazines want as many as 100 trannies of each girl to select from. Quite honestly, it is a market which is extremely difficult to break into for a professional, let alone an amateur. You would be better advised to start with trying to get pictures of pretty girls into your local paper, then work up to the family newspapers who use mostly professional work. There are some cheaper pin-up magazines but *you must read them before trying to take pictures for them.*

Don't forget that pictures reproduced in newspapers

This position we used to call a 'cover up' shot. She is not wearing a top, but still does not not show anything. An adaptation of my 'basic pose' by Minerva Smith.

176

lose technical quality so make the lighting strong and clear, the printing in the darkroom, sharp and punchy, and the backgrounds as plain as possible. For selling to newspapers, keep the posing compact to fit easily into a double column. Lying down or 'sideways' pictures do not fit the newspaper format so easily, so do not sell so well. An arm or a leg posed 'sticking out' from the body might have to be cut off so could be rejected purely because of that.

Some newspapers only use glamour pictures taken by staff men or union member freelances, but if there is a strong story attached to one of the girls you have taken (ie. she might be a witness in a murder case) they will be interested in any picture of her, because it becomes news and not feature and the unions cannot object.

Picture libraries and press agencies

Selling straight to publications is not the only market for your pictures. There are also posters, calendars, greeting cards, confectionary boxes, jigsaw puzzles, records, advertising and books. These are best reached through a picture library who handle all the selling for you and may take 50 per cent of the sales revenue. However, it is highly unlikely that you would ever reach these markets on your own. There is a catch. The best are only interested in representing someone who can produce about 100 trannies for starters and virtually guarantee at least another 100 a year in batches of 40 or over. The subjects do not have to be glamour. A good photolibrary will send you full details. Listing the subjects they want ie. cities and landscapes, tourist attractions of all kind, mood scenics, children, glamour, bikini girls, nudes, still-life, classic automobiles, flowers, wildlife, birds, sport, snowscenes, sailing, etc.

Every photograph must be of high technical quality. Most still-life and flower photography is on 5×4 inches or larger format, so if you send in 35 mm or 6×6 inches of these subjects they are less likely to sell. If 35 mm is

Look how well Eva Rueber Staier (Miss World 1969) uses her body and hands for this unusual newspaper glamour pose.

178

accepted most publishers insist on Kodachrome for its excellent definition.

Press agencies sell more to publications but often have the normal library outlets as well. They do not mind looking at your pictures but you must send a proper self-addressed envelope for their return. Do not expect them to send you a lengthy letter full of helpful criticism and comment. They don't have the time. Frank Selby of Rex Features told me he was inundated with a load of rubbish from amateurs after some publicity in the press, and none of it was usable. Half the people did not even send stamps but expected comment on their work!

Many agencies and libraries are listed in the classified telephone directory but their association might send you a membership list, if you are polite and twist their arm! Their address is BAPLA PO 93, London NW6 5XW. And don't send them rubbish, wait till you get a good collection together.

Private selling

Even if you do not aspire to full 'glam' after going through this chapter, I hope you will have learnt that glamour technique is basically flattering the subject. There should be a market for you to sell pictures to the people who sit! If you can take a picture which is a good flattering like-ness of somebody's daughter, son, father, child, mother, the rest of the family are going to be interested in owning a copy. Don't give them away—charge.

Summary of glamour photography

1 You cannot go straight to the top of glamour photo-graphy.
2 Learn by research and cutting out pictures from news-papers and magazines, to help you with style, posing and lighting.
3 Work out from these, and the picture in this book, poses that you can ask the model to do.

4 Search for models who are interested in being photographed, want to look attractive and want to 'glamorise' themselves.

5 Do not start glamour pictures until *you* are efficient with your camera.

6 When you have made your first date with a model, spend time discussing make-up, clothes and poses with her, before shooting.

7 Before she arrives, have your basic lighting, exposure, locations and ideas worked out, whether in or out of the studio.

8 Be *so* efficient with your equipment that you can nearly forget it and concentrate on your subject.

9 Do not start shooting the model until you are sure that *she* looks as good as possible.

10 Only start trying to sell when you have a 12 good glamour sets in your portfolio.

11 Do not start trying to be clever too early.

12 Results depend on your standard of professionalism, your direction of the model and the standard of the model herself. A top photographer might get away with finding and photographing a new girl. A top model might make a beginner's work look pretty good. An average photographer, working with an average model, will produce average results.

13 *A top photographer working well with a top model will produce winning pictures every time.*

Selling

1 Research your market, by buying all the publications to sell to, before shooting to sell.

2 Reproduced pictures lose quality, so shoot sharp, strong pictures with simple backgrounds.

3 For the same reason, overglamorise the model, with make-up and exaggerated clothes.

4 Pick the models with the best possible story or background. Actresses sell better than secretaries. After the session, list their achievements, hobbies and ambitions,

however outrageous, and, if they have none, invent some between you. ('I want to sail single-handed round the world' is better than 'I want to be a model'.)

5 Cheeky, fun, sexy, provocative poses sell better. 'Chin down eyes up' is a good rule. Use small props, like sunglasses or beads to vary poses. Organise several changes of idea and clothes to give you more alternatives to sell.

6 When showing or sending pictures to an editor present them well. Pictures should be at least 10 × 8 inches and properly captioned, with a self-addressed envelope if you want them back. Don't expect a letter of criticism from an editor.

7 If at first you don't succeed, try, try and try again.

8 *Don't use your camera as an excuse to get a girl to strip.*

18

Freelancing and Becoming Professional

I know that most amateurs have no wish to become full-time professional photographers, but some may want to take it up as a weekend job to make a bit more cash. Others still might want just to do an occasional freelance job. I have described how I got into it all, and how one young man I met goes from door to door freelancing his child photography.

There are various ways of freelancing. As far as selling to newspapers, magazines and other publications goes the same basic rules apply as for selling glamour. It is essential to research your market. Many people try selling to their local paper. They should read the local newspaper regularly and get an idea of what sort of picture stories would interest the readers. They should also contact the picture editor and find out their rules about payment and whether the unions block outside contributions or merely payment for them. One lady I know sent up a series of pictures of local interest and a story line and the editor said 'We would like to publish the pictures and stories on the old folk, but I am afraid we cannot pay you. All we can do is send you ten reels of film'. Of course they published her name as a 'photo credit' so she settled for that.

I sent a set of pictures of our daughter Georgina when she was three 'taking pictures' with a toy camera of our son William when aged one month. I wrote a story line to the effect that she was 'following in father's footsteps' and sent it off to my agent for selling portraits and feature stories, Camera Press. Four months later we were surprised to find on our statement that they had sold something they called 'Young Photographer of the Year' three times abroad. They had rewritten the story line and sold it to Switzerland, Germany and Holland!

It is a good idea to combine any other hobbies you have with your photography. If you sail, study the sailing magazines and see what they publish. Because you sail, you should be able to spot an unusual or newsy event, such as a well-known yachtsman capsizing in a race, whereas all the yachts look alike to the rest of us.

183

It is worth joining the Bureau of Freelance Photographers for their newsletter alone, and also Mallinson's School of Photography. Newsletters give the latest requirements of many and varied publications. If you get your credit under the published pictures and always keep a scrap book of work published, it helps build your name with the general public and other editors.

If weddings interest you, research by watching the photographers in operation at the local church (the verger will tell you when they are to take place). Watch from well back how they work. Don't take any pictures at this stage. Obviously take pictures at your own family weddings but don't accept a commission to do the official pictures. The next stage is to ask the local photographers if you can assist them in any way, for no fee, even if it is only by driving them from one wedding to another and helping 'hump' their gear. You can explain that you want to learn more about the trade and possibly, eventually, for a small fee you might be able to do the odd straight-forward job for them when they have more than they can manage. Remind them that it will bring in extra profits to the firm. A person of any age can try this. A school leaver might do the rounds and offer his services for a very small sum full time to learn the trade. This is the way I turned from amateur to professional after the advice Tony gave me, if you remember.

Schools

The photographic colleges are really only good training ground for those who want a job *in* photography and have no desire to be their own boss. If you want a job in the photographic department of a big firm, technical know-how and qualifications from such a college would help. But if you are a loner they don't teach you the business of photography, so it is better to start at the bottom in a studio, shooting the kind of work you eventually want to do. In the UK there are some good state run schools but I believe that the private ones give a better, faster and more

Picture of John Downing, award winning photographer of the *Daily Express*, taken at a private wedding. This illustrates that top pros are always looking for new angles and vantage points!

personal tuition, if you can afford the fees!. Mallinsons is the best I know. If you are already in another job and want to change, try going to an occasional weekly, weekend or one-day course advertised in the small ads of *The Practical Photographer* and *Amateur Photographer* for instance.

I know a man of sixty, who is a hearing aid specialist. He is leaving his profession because of changes in the health service. He came on two of my courses, to learn how the professional works and has now found a small photographer's shop with a flat above in a seaside town for a rent of £5 per week. Pretty enterprising!

Never stop reading books and magazines and keep up to date. Freelancing is not just the business of selling to publications. You would be surprised how many people would like a nice picture of their house, dog, cat, as well as their children. If you cannot face 'door-to-door' selling publicise your intention by putting it around in your local club or pub. It is a great profession with wonderful job satisfaction if you can get into it—but don't forget it is already crowded.

19

Tricks of the Trade

I think it will be useful here to sum up and add some of the tricks of the trade that professionals use. Obviously everyone works out their own way of doing things, but certain points are useful to note.

Gentle flattery

There is no point in shooting the worst part of somebody's character or face. It will not sell to him. Karsh of Ottawa makes all his subjects look 'important'—the unknown business man looks like the President of the USA! I try and make all my businessmen look like pleasant people (and that goes for politicians too). Anyway everybody has a nice side and I prefer to believe that everybody I meet is nice until proved otherwise!

Flattery can be done partly in the darkroom. I prefer to shoot sharp, and diffuse under the enlarger with a Rolleisoft 0 or Rolleisoft 1 according to the need. This is not so easy in colour but colour is more flattering anyway. My instructions to my colour lab are always 'Make everybody look fit and healthy!' Colours look different in different light (outdoors they will look more bluish, indoors more reddish) but not many complain that the dress was the wrong colour in the picture. She may have had a ghastly white face and the labs have given her a bit of a 'tan' so the dress might be a bit off but you can always say 'I was trying to get her complexion right and was taking her face not her frock!'

In the darkroom, after getting a girl to darken her eye make-up and lipstick you can print her lighter and softer giving her a pure complexion. On the other hand, if a man has a tan and is good looking anyway or has a great character face, I print it right through to the skin detail. Another form of flattery is to really know your client or subject (they may be different people) by reading them up, asking mutual friends about them, watching their programme on TV before you meet or whatever. The British tend to shy away even from mild flattery and qualify it with a small criticism.

187

Carry a spare

Every professional worth his salt always keeps in his studio, or car a spare of everything. I take two standard Rolleis and a wide-angle to a wedding. There is nothing worse than having to say 'I cannot go on, my camera is broken.'

Angles

Shooting from below will make a person taller, especially with a moderate wide angle for a full length shot. Also a super wide will make the room of a house you are selling look bigger, and, for that matter, the house too, if you are shooting from the outside. Shooting down slightly on a person's face with a portrait lens will enlarge eyes and reduce chins. Asking them to lean towards the camera also reduces those extra folds of flesh. Nobody will hate you for making them look better.

Sales patter

The soft sell is best in our profession although I heard a speech from a very tough lady who is receptionist for her husband's business in the north of England. She would never quote over the phone but always got the clients into her 'lair' where she could 'show' them all the services they could offer. If one has no showroom a good telephone voice is essential. If you don't feel like going from door-to-door yourself, you could put up your prices, train a pretty girl in all you can do, give her a sample book of your best work (ie. the most attractive people you have taken!) and get her to go out selling on commission.

Publicity

When starting up it is essential to get as well known as possible. Word of mouth is all very well but it does need supporting with press and other publicity. Most local

wedding photographers don't sell their pictures to the local paper, they give them in exchange for a by-line. When I used to get regular pictures of pretty girls in the William Hickey column in *The Daily Express,* with my name under, it reminded old clients and spread my name to new ones.

Going for a job

If you want to join a photographer or sell to a newspaper or art director, always present yourself and your portfolio as well as you can. Dress tidily, be polite, always ask for their advice (people like that) and to point out the faults in your pictures. Never turn up in dirty old jeans with un-washed hair and a random selection of tatty prints in an old envelope. Professional salesmen know this art.

Charities

At local charity events, offer a prize (fully acknowledged in the programme and by the announcer) of a free sitting with 3 free portraits of their choice, and try and attend the event. It will not cost you a lot and may not pay dividends straight away, but the word gets round how generous you are and you *have* helped the charity. I had to stop this because they all started pestering me. Get to know the toastmaster at the event so that he does not forget to mention your name as often as possible. Try and get on radio and TV, even if it is only local, or a phone-in programme and mention that you are a photographer from XXXX.

20

The Secret of Success?

When I was a schoolboy I had no strong ambition to be a good schoolboy, so I wasn't. I was forced onto being a soldier for National Service, so my only aim was to get through it as quickly and easily as possible, so I did. I became a stockbroker's clerk, because I had no real idea what I wanted to do, and that was the type of job my friends were doing. I thought at the time that one had to suffer a job in order to enjoy oneself in the evenings and weekends, and eventually support a family. It was not surprising I was not a good stockbroker, because I danced the night away with the debs and slept over my adding machine in the office! During this time I picked up the camera I had used in my army days and started photographing girlfriends in my shared flat because it was cheaper than taking them to night clubs! My friends brought their girlfriends along and I derived great pleasure from the praise I received from a *successful* sitting.

Then I went through the stage of self-questioning. 'Did they really mean it or were they being polite?'. However, some people framed them and put them on their pianos, others came back and said 'Can't I buy a few more copies?' (I was still at the second-hand rickety photoflood stage.) But it gave me the idea that maybe I was on to something I could be a success at.

So I acquired an ambition (I had never had one before)—to be a good photographer of people. The results were, and still are, the important thing. I am more concerned that the clients are happy with the photos than with the size of the order. Rather like the ham comedian who prefers the applause to the money—not very businesslike.

Then there are others who aim to become good enough to win competitions or have their work exhibited. I asked one chap, when I was chatting (I seldom 'lecture') during one of my home courses what he wanted to *do* with his pictures. He said he wanted people to see them. He too wanted applause in his own way, and in fact that was the attitude of most of the advanced amateurs. They were not interested in selling for success, but they wanted to be judged by their equals and found good. If they *are*

found good in their own sphere then they have succeeded.

One of the greatest accolades for the normal amateur is to become an FRPS and, for a local photographer, an AIBP. For both, one has to achieve a high standard of technical and artistic ability. Being a bit of a rebel, I never wanted to be either of these. I did not even know much about them when I started. I admired the top professional photographers of the day—Cornel Lucas, Cecil Beaton, Houston Rogers, Bill Brandt, Richard Avedon, Norman Parkinson, Tony Armstrong-Jones (Patrick Lichfield started five years after me!) and I wanted to be successful as a national name like them. Aiming for the stars! Let us take a look at some of these and later big names; their styles and possible reasons for success in their own fields. It may seem a little cheeky to comment on them (even with trepidation) but there is no jealousy between the top men in any profession.

Karsh of Ottawa is possibly the best known portraitist in the world of men. I say 'men', because I have seldom liked any of his portraits of women that I have seen. Everybody knows the famous pictures of Winston Churchill and Ernest Hemingway. I have already mentioned that he makes unknown men look important. I have never met him but would love to. Betty Kenward writing as Jennifer in *Harpers and Queen* recently described a visit to his home. There was not a photograph to be seen! He was delightful relaxed company. I have also been told that he takes a very long time over each sitting. He uses a large plate camera and fusses over every fold of a dress or robe, every angle of light, the pose of every finger until, in his opinion, it is worth exposing the first plate. His method of work is to spend a portion of the year shooting the famous or, shall I say, asking them to pose for him. Of course he does not charge a sitting fee, but he instructs his agents to charge large reproduction fees for the results when published. Another part of the year he sets aside for people who ask him to take their pictures and charges enormous fees, and who can blame him? His style is to

show the character of the man in his surroundings. (He has been to the White House for every president, as far as I know.) There can be no criticism of his work or his methods, and no one has been able to copy his style. No one knows all the secrets of his art because a lot of it must be his personality.

Cecil Beaton, on the other hand, is more a designer or artist who happens to use a camera. In his photographs it is the whole picture that has to be pretty, beautifully composed and a work of art in its own right. After all he is a great designer. Think of *My Fair Lady* for which he designed the clothes and, I believe, the sets for stage and screen. For me his portraits never tell me much about the subjects personality. They are often just part of a beautiful picture. They are actors in his 'sets'. Funnily enough when he writes about people he describes their characters so well, you feel you know them. Do not think I am being unkind, I am trying to analyse.

Tony Snowdon I have mentioned him a lot already because of the help he gave me when I started, and the fact that I have followed his work closely ever since. The last time I talked to him (we have not kept in contact) was just after his engagement to Princess Margaret, when I was asking him what to do about joining Dorothy Wilding. I remarked 'It is a pity we may not be seeing so much of your work in the future.' He said, 'Not to worry, I have always felt I am more of a designer than a photographer'. So maybe he is a designer with a camera in his hands. It shows in his pictures. Look at the balance and shape, strong and simple, that comes through. He changed photography in the late fifties. He broke established rules. He used increased grain to make a stronger design in his pictures. (I expect the RPS held up their hands in horror in those days, as probably Kodak did, who have always been trying to minimise grain in their products and he almost made it popular!). When he married he did put his photography to one side for a while and concentrated

on making people more aware of good design, but then he moved on into movies and telling stories using the extra media of colour and sound and movement. And yet? He is asked to do the pictures of Princess Anne for her 28th birthday with her husband Mark and Master Peter Philips (You notice the Royal family is dropping the use of Royal Highness.)

Norman Parkinson Of all English photographers he is my 'great white god'—his fashion pictures are out of this world. If only I could take pictures like him! He is partly responsible for me giving up fashion photography, just as, when I heard Larry Adler play the mouth organ at a concert at Eton, I threw away my mouth organ which was the same model as he used, because I was exasperated and knew I could never play like him! As I say, the Royals found him late. I wish I could have worked for him for a period to see how he does it, but I already had my own business to run before I realised how good he was. Models who have worked for him have told me that he is the sweetest and nicest man to work with of any they knew. That I can believe.

David Bailey came to fame in conjunction with the great Jean Shrimpton, whom I photographed before she met him when she was straight out of Lucy Clayton's modelling school. The two sparked off something between each other and the results were just what *Vogue* were looking for. All the other publications followed *Vogue!* I think he was one of the first to bring a little eroticism into fashion photography. I know he and his contemporaries (Brian) *Duffy* and (Terry) *Donovan* are great experimenters with every new camera and technique, although they all say they use Olympus! Duffy, in the early days of the Association of Advertising, Fashion and Editorial Photographers was interested in photographers forming a union. In the early days I often felt that his work seemed derivative in style but since then he has really got to the top and found his metier.

Terence Donovan is always a lovely easy going person who smiles a lot. His work is more exact and practical than that of comparable photographers and, possibly, he is a better businessman. When TV advertisments boomed he moved over to making them. Now they have slumped I see he is doing stills jobs again. Any young man who wants to be a great fashion and advertising photographer, should try and get a job making tea in his studio.

Richard Avedon I have never met him, but from what I have seen of his work he must be one of the greatest of all American fashion and advertising photographers. He gives punch, strength, super professionalism, and generally everything to every shot.

Patrick Lichfield He is a top class photographer as well and extremely professional. He has been constantly in the news and possibly over publicised in silly ways, but his photography no one can complain about. It is difficult to see how anybody can have a 'jet set' reputation and still be taken seriously by advertisers for his photography. But he is, so well done!

Bill Brandt is a photographer's photographer. He is admired universally by other photographers for his originality. He is incredibly inventive, and if the advertising boys need a little help in producing an unusual eye-catching advertisement it is to him they turn.

Monty Fresco of *The Daily Mail* is one of the cleverest Fleet Street boys. *Geoff White* now of *The Daily Mail,* and *Ted Blackwell* travel the world and are all experts in 'people'. *Vic Blackman* of *The Daily Express* has many years of experience under his belt and tells us all about it each week in *The Amateur Photographer. John Downing* is their photographer of the year. *The Daily Mirror* has a host of talent at its disposal including *Freddie Reed* who has been with the paper 50 years, *Doreen Spooner,* one of the few lady Fleet Street photographers,

and who does quite a lot of their glamour photography, strangely enough, but it may be its easier for a new model to take her clothes off in front of a woman than a man. *Kent Gavin* and *Arthur Sidey* have also been with the paper for years. I asked Derek Frabis on the picture desk of *The Daily Mirror* what he thought was the talent of these Fleet Street photographers in relation to photographing people and he said 'The fact that no matter what assignment you send them on, they bring in the best possible pictures'. That is how to be successful in Fleet Street.

I could go on and on talking about famous and successful photographers but let us get back to general topics involving success.

I was chatting to an acquaintance in a pub recently and he said, 'I always think of photographers as artists who use a camera to make a picture because they cannot draw or paint one.' I nearly spilt my beer because I really thought photography had received better acceptance as an art form than this.

However it made me think, and I realised that I did know a few photographers of whom this could be said. However, anybody who thinks seriously about this subject must realise that the camera gives us far more scope to produce images than the painter can ever achieve. Anyone who aims to use his camera purely to produce a portrait or a landscape, which a painter could do better, is not using his photography to the full. A painter has to select one expression of a sitter, when painting a portrait, and takes many hours to do it. We can produce many images of that person in a few minutes and many sides to their nature. We can also vary the lighting and the setting. However we must get to know that person quickly, so that we can recognise those different sides. Although some photographers use the surroundings to help 'give light' to a person's character I have always concentrated on the close-up portrait. Obviously I change the lighting to emphasize different aspects of the features.

The success of a professional photographer is not measured by the amount of money he makes; a camera shop owner probably makes more than most.

Fame is only relatively important. A small town portrait and wedding photographer only has to be well known in his own area to be successful. A West End or London 'Society' photographer needs to be known throughout the country to the people who are likely to want his services. Larger fees are needed to support a Mayfair studio than if he was working from home or a local studio. On the other hand, if he is an acknowledged success, he can charge reasonable fees, and can therefore spend more time and trouble, film and paper on any given job, which, in turn, gives him a better chance to take pictures.

The top commercial photographers are virtually unknown to the general public outside the world of advertising. You seldom see the name of the photographer on an advertisement. But they are very well known in the advertising world to the art directors who employ them. Some become famous through fashion photography and the gossip columns, but their fame would quickly fade if they did not take good enough pictures when required.

One mark of success for a portrait or wedding photographer is to be asked to take pictures of the Royal family. For a fashion photographer it would be for *Vogue* to ask him to do a cover and an inside spread. For glamour photographer, a set of pictures for *The Sunday Mirror*. For the nudie photographer a centrefold spread for *Playboy*.

I have talked about some of the big name photographers who have been successful. They have all achieved this through very hard work, a good business brain, a touch of showmanship and, oh yes, a lot of stamina! None of them would have achieved fame or success unless they had the drive and ambition to do so.

So there you are. Set your sights high and have a go. I wish you the best of luck but don't forget it is the hard work you put into it, that often 'creates' the luck.

Index

197